Modernism: A Very Short Introduction

VERY SHORT INTRODUCTIONS are for anyone wanting a stimulating and accessible way into a new subject. They are written by experts, and have been translated into more than 45 different languages.

The series began in 1995, and now covers a wide variety of topics in every discipline. The VSI library now contains over 500 volumes—a Very Short Introduction to everything from Psychology and Philosophy of Science to American History and Relativity—and continues to grow in every subject area.

Titles in the series include the following:

Christopher Butler

MODERNISM

A Very Short Introduction

OXFORD
UNIVERSITY PRESS

OXFORD
UNIVERSITY PRESS

Great Clarendon Street, Oxford OX2 6DP

Oxford University Press is a department of the University of Oxford.
It furthers the University's objective of excellence in research, scholarship,
and education by publishing worldwide in

Oxford New York

Auckland Cape Town Dar es Salaam Hong Kong Karachi
Kuala Lumpur Madrid Melbourne Mexico City Nairobi
New Delhi Shanghai Taipei Toronto

With offices in

Argentina Austria Brazil Chile Czech Republic France Greece
Guatemala Hungary Italy Japan Poland Portugal Singapore
South Korea Switzerland Thailand Turkey Ukraine Vietnam

Oxford is a registered trade mark of Oxford University Press
in the UK and in certain other countries

Published in the United States
by Oxford University Press Inc., New York

© Christopher Butler 2010

The moral rights of the author have been asserted
Database right Oxford University Press (maker)

First published 2010

British Library Cataloguing in Publication Data
Data available

Library of Congress Cataloging in Publication Data
Data available

Typeset by SPI Publisher Services, Pondicherry, India
Printed and bound by
CPI Group (UK) Ltd, Croydon, CR0 4YY

ISBN 978-0-19-280441-9

Contents

List of illustrations

The Publisher and the author apologize for any errors or omissions in the above list. If contacted they will be happy to rectify these at the earliest opportunity.

Chapter 1
The modernist work

It appears likely that poets in our civilisation, as it exists at present, must be *difficult*. Our civilisation comprehends great variety and complexity, and this variety and complexity, playing upon a refined sensibility, must produce various and complex results. The poet must become more and more comprehensive, more allusive, more indirect, in order to force, to dislocate if necessary, language into his meaning.

T. S. Eliot, 'The Metaphysical Poets' (1921)

> Apocalyptic chimney cowls
> Squeak at the sergeant's velvet hat
> Donkeys and other paper fowls
> Disgorge decretals at the cat.

Parody by J. C. Squire of a quatrain poem by T. S. Eliot

This book is about the ideas and the techniques that went into innovative works of art in the period from 1909 to 1939. It is not, primarily, about 'modernity', that is, the stresses and strains brought about within this period by the loss of belief in religion, the rise of our dependence on science and technology, the expansion of markets and the commodification brought about by capitalism, the

growth of mass culture and its influence, the invasion of bureaucracy into private life, and changing beliefs about relationships between the sexes. All of these developments had significant effects on the arts, as we shall see, but my main theme here is the challenge to our understanding of individual works of art.

We can get a good preliminary idea of the nature of modernism in artistic work by looking at some of the difficulties that Eliot had in mind; so I am going to take a novel, a painting, and a musical work, and ask what they can tell us about the nature of art in their period. (All three centre on a great aspect of modernity: life in the city.) Through them, I will try to show how innovatory techniques and modernist ideas can interact. In doing this, we have to come to terms with some difficult problems of interpretation, as they all deviate in interesting ways from the 19th-century realist norms, on which we still generally rely to understand the world. But novels like *Middlemarch* and *Anna Karenina* (even though they are focused on the tensions brought about by new claims for the status of women) seem now to come to us from a relatively stable intellectual framework, presented to us by a more or less friendly, perspicuous, and morally authoritative narrator, who creates for us a world which we are expected to recognize, and which belongs to the past. But modernist art is far more indirect – it can make the world seem unfamiliar to us, as rearranged by the conventions of art.

Ulysses

The opening words of James Joyce's *Ulysses* seem initially to come from the realist world, but the appearances are going to be deceptive, and they become more so as we go through the novel, and its stylistic deviations become more obvious, even though they are at base founded in remarkably accurate history.

> Stately, plump Buck Mulligan came from the stairhead, bearing a
> bowl of lather on which a mirror and a razor lay crossed. A yellow
> dressing gown, ungirdled, was sustained behind him by the mild
> morning air. He held the bowl aloft and intoned:
>
> - Introibo ad altare Dei.
>
> Halted, he peered down the dark winding stairs and called up
> coarsely:
>
> - Come up, Kinch. Come up, you fearful jesuit.

The primary modernist technique here lies in Joyce's making of
allusions, which lead us to feel the presence of underlying
conceptual or formal structures. And so, as Hugh Kenner notes in
his brilliant guide, in this book, whose narrative will parallel that of
Homer's *Odyssey*, the first nine words mimic the rhythms of a
Homeric hexameter, and the bowl Mulligan bears is also, in the
parallel world of allusion, a sacrificial chalice on which his shaving
gear lies 'crossed'. His yellow dressing gown echoes a priest's
vestments – for those days when no other colour was specified – in
gold and white. And furthermore, 'ungirdled' (the cincture not tied
as it would be for the priest's ritual affirmation of chastity), it leaves
him frontally naked, his private parts on display for mild air to
caress; he is aware of that too. And 'intoned' is deliberate;
preparing to shave, he is also playing at the Black Mass with its
naked priest. The words he speaks, which belong to the Ordinary of
the Catholic Mass, come from St Jerome's Latin version of Hebrew
words ascribed to a Psalmist in exile: 'I will go up to the altar of
God.' It is therefore a quotation of a quotation of a quotation, and
originally a Hebrew cry for help amid persecution.

Of course, the first-time reader doesn't notice all this – or, perhaps,
need to – but the book as a whole sets up such echoes, which make
for our awareness of significant structural parallels. So Kenner also
notes that:

On a later reading we may also remark the appropriateness, for the book of Bloom – its Jewish hero: the modern Ulysses – of an initial statement in disguised Hebrew, and note, too, that as the Roman priest adopts the role of the Psalmist, so Irish political consciousness in those years was playing the role of the captive Chosen People, with Great Britain for its Babylon or its Egypt.

Ulysses is paradigmatically modernist, at the very least because, like *The Waste Land* and the *Cantos*, it is a work of allusive and encyclopaedic interconnectedness, with an immense concern for cultural changes within the life of the city. One of the things that Joyce gains from this, for the novel, is a mythical as well as an historical organization of narrative, and so also a means for comparing cultures in variously satirical ways: how are the Irish a persecuted 'chosen people'?

Many of these techniques are central to our understanding of a great deal of modernist art, and I am suggesting that we can diagnose the 'modernist object' (whether picture, text, or musical work) along these two dimensions: of a provoking new idea and of an original technique. For Joyce (and Eliot and Pound, and indeed Milton and Pope before them), it is the ideas of cultural comparison and simultaneity which are made possible by a technique of allusion within the text.

La Ville

In Fernand Léger's huge *La Ville* [*The City*] (1919) (Illustration 1), we have to confront the influence of the cubist painting of Pablo Picasso, and of Georges Braque (the latter exemplified in Illustration 2), who had been described in November 1908 by the art critic Louis Vauxcelles as 'an exceedingly audacious young man ... [who] ... despises form, reduces everything, places and figures and houses, to geometrical complexes (*des schémas géometriques*) to cubes'. This 'reduction' is part of a general tendency towards abstraction in modernist painting, to be found in varying

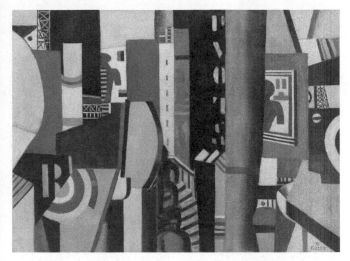

1. Fernand Léger, *La Ville* (1919). Cubism as a collage of our perceptions of the city

ways in Henri Matisse, Juan Gris, Wassily Kandinsky, Piet Mondrian, Joan Mirò, and many others. The effect of this on painters like Léger was partly to make geometric pattern or design a main feature of their work, because the cubists had destroyed, from 1906 to 1912, the realist conventions for three-dimensional perspective which had been dominant in art since the Renaissance. Objects in cubist pictures were contradictorily represented, from more than one angle of view within the same picture plane, and this brought about:

> the construction of a painting in terms of a linear grid or framework, the fusion of objects with their surroundings, the combination of several views of an object within a single image, and of abstract and representational elements in the same picture.

This seemed to many to be the master artistic innovation of the modernist age, and most painting since then has been affected by or defined itself in relation to it. It involved a radical deviation from

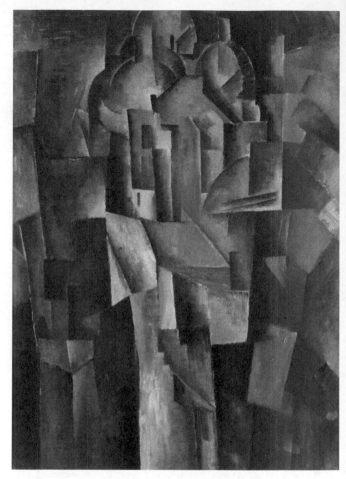

2. Georges Braque, *Le Sacre Coeur* (1910). The picture and the building have competing kinds of geometrical architecture

realistic illusion, and in Léger's painting we can see this influence. It was described by Kirk Varnedoe as a 'utopian billboard for machine age urban life'. We can see how it has elements of receding perspective, such as the stairs in the middle, which are yet contradicted by or inconsistent with the overlapping planes to left and right. There are girders, a pole, what may be a wall poster, possibly a funnel on a ship, but they do not make a single coherent scene. They are patterned into an overlapping collage of quasi-representative shapes. Things which 'ought' to be seen as near or far, and so on different scales relative to one another, are not in perspective (for example, the tubular human figures). Objects here are not ordered according to conventional representational means, but are juxtaposed by the artist into simultaneity within the plane of the picture. Léger has arranged a number of city-like, geometrically distinctive elements, to make an abstract design. (A very similar art, of contrastive juxtaposition rather than logical linkage, is to be found in the poetry of Guillaume Apollinaire and T. S. Eliot by this time.) Many cubists used popular materials (wine glasses, sheet music, newspapers, and so on) as the basis for their painting, and so it is tempting to see *La Ville* as also mimicking the effects of big publicity posters in the city (so that James Rosenquist's pop-art representations succeed Léger in this respect).

Once again, two aspects of the culture, a 'high' formalism and a 'low' popular content, confront one another, and this kind of interaction is tremendously important for modernism. Léger's work is modernist because it exploits a new language or syntax for the painting, in new principles of organization. Its elements do not fit together in anything like the way that they do within realist conventions. The resemblance of parts of the painting to the world remains for us to discover, but it also depends on our learning to appreciate modernist modes of abstraction, and the ways in which they may satisfyingly fit into a design.

The Threepenny Opera

Not all modernist works are as obviously experimental. My musical example is superficially much easier to understand – indeed, it is essentially popular in form, full of contemporary dance rhythms spiced up by modernist 'wrong notes'. *The Threepenny Opera*, written by Kurt Weill to a text by Berthold Brecht, follows John Gay by using popular (but in this case original) tunes, which make the work far closer to cabaret than to Verdi or Wagner. Brecht's late Victorian, Soho-based crooks, beggars, and bankers run in a sustained contrastive parallel to the rogues of Gay's original *Beggar's Opera*. In Gay, Peachum is a receiver of stolen goods; in Brecht, he organizes a mafia of professional beggars. The musical procedures are often a parody of earlier styles, so that allusion features yet again, for example, in the overture, which has Handelian moments and an attempt at a fugue. This stylistic instability has an important function: it is supposed to make it more difficult for us to become as continuously and sympathetically involved with the characters as we would in earlier opera, so that:

> When singing, the protagonists 'adopt attitudes' rather than tell us anything about their true character or emotions, which strictly speaking they do not possess, at least in any conventional sense. The relationship between words and music is deliberately untautological and ambiguous; the words can say one thing, the music something else.

And there is a stage narrator, who produces a detached 'epic' narration of events. (In the 1928 libretto, which Brecht thought to be a successful experiment in a new kind of 'epic theatre', producers were encouraged to project the interconnecting narrative texts on screens.) It is an early use of those distancing or 'estranging' techniques which are important for the later development of Brechtian political drama, as we shall see. What is

distinctively modernist here is a hostility to 'bourgeois' notions of sympathy and involvement, as associated with traditional realism (as in the *'verismo'* of Puccini, or in the action of *Der Rosenkavlier*, despite its quasi-parodic relationship to the Viennese waltz). Hence Brecht's invention of various liberating, critical, alienation effects, designed to help audiences, not to 'consume' the work, but to step back to reflect upon the political significance of the characters in the story, rather than to identify with and feed on their feelings as individuals. In the original version of the final execution scene, Mack the Knife (i.e. Macheath) steps out of his role to argue, against the voice of an off-stage 'author', that the play doesn't need to end with his being hanged.

In common with much modernist art, it distances itself from the past by parodying it. The 'moritat' motif associated with Mack the Knife is a crude parody of the Wagnerian assignation of musical leitmotif to character. The sentimental ballad of a pimp, and the caricatured love duets of Mackie and Polly, are grotesque. *The Threepenny Opera* is against expressionist individualism, and anti-romantic. As Weill put it in an interview of 1929, with a typically leftist 'after this, no longer that' rhetoric: 'This type of music is the most consistent reaction to Wagner. It signifies the complete destruction of the concept of music drama.' And Felix Salten (in reviewing the 1929 performance in Vienna) said that the music is 'as electrifying in its rhythm as the lines of the poems, as deliberately and triumphantly trivial and full of allusions as the popularizing rhymes, as witty in the jazz treatment of the instruments, as contemporary, high spirited and full of mood and aggression, as the text.'

Stylistic variation

These are works which point in all sorts of different directions, and it would be misleading to use them to make any strict boundaries for 'modernism' or to offer a 'definition' of it. It was all sorts of things, and this plurality and confusion was obvious at the time, as

we can see from the contradictory definitions and interpretative strategies which were then applied to new works of art. For example, when F. S. Flint, a collaborator with Ezra Pound in promoting the so-called 'Imagist School' of poetry, saw *Parade* (1917), which combined Erik Satie's popular music-derived score with cubist costumes by Picasso and an entirely absurd libretto by Jean Cocteau, at the Empire Leicester Square in London, he asks:

> What phrase can describe it? Cubo-futurist? Physical vers-libre? Plastic jazz? The decorative grotesque? There is no hitting it off. The programme is of very little service. It tells you that the period is eighteenth century and the subject the vain efforts of showmen to lure the public inside their booths. But you begin to wonder whether the programme's analysis of the newly presented ballet is not just another bit of M. Massine's fun, when you discover the 'American Manager' disguised as a skyscraper, and 'The Manager' as another architectural joke, and 'The Circus Managers' bumped together into the most comical pantomime horse that ever was seen. M. Massine as the Chinese Conjurer is recognisable, so is Mme Karsavina as the ridiculous American child, not of the eighteenth but of the twentieth century, wearing a sailor coat and a huge white bow in her hair: and there is no mistaking Mlle Nemtchinova and M. Zverev as the acrobats in their skin-tight blue.

By this time (November 1919), there were, for Flint as for everyone else, many new styles and techniques to be found in contemporary art, because of the great efflorescence of technical change from 1900 to 1916. In painting, the fauvists, following Gaugin and Vincent Van Gogh, had abandoned local colour, so that a tree could be blue; the cubists had abandoned single-point perspective; and Kandinsky had moved towards an abstract painting which did not seem to present real-world objects at all. Joyce was already well into the most experimental episodes of *Ulysses*, which were all written in widely divergent styles, using all the figures of the rhetoric books in 'Aeolus', a musical deformation of morpheme and syntax in 'Sirens', parodies of the prose styles from

Anglo-Saxon to modern American in 'Oxen', of popular fiction in 'Nausicaa', and pretty well every form of Dadaist, expressionist, and surreal fantasy in 'Circe', and much more. Arnold Schoenberg and his followers had invented an atonal music which, rather like cubist painting, refused to coordinate the work by reference to central tonal organizing points, so that the hierarchy of chordal relationships that had ruled for centuries had been abandoned, and a new freedom of association between sounds had been invented. Igor Stravinsky had made never-before-heard and wildly irregular rhythmic constructions in the *Sacre du printemps* (1913) and the poetic experiments of Guillaume Apollinaire and Blaise Cendrars, Ezra Pound and T. S. Eliot, August Stramm and Filippo Tommaso Marinetti, had collaged and juxtaposed fragments of narrative and imagery, leaving out many of those syntactic and logical connectives which had previously articulated a story for the reader.

All this led to a stylistic variation in each of the arts that was central to the modernist period. Picasso is the classic exponent of this, and was a great stealer from others. Through his early career he develops from early Impressionist imitations, through to a 'Blue Period', and then a cubist, and then a neoclassical one. His development is not linear, but cumulative and overlapping: like Joyce and Stravinsky and Eliot, he has many styles of expression available. For these modernists, the canon of past art is always available for reinterpretation, imitation, and even parody or pastiche. 'To me there is no past and future in art', said Picasso, and in the end, it's the personality of these artists that holds things together (and that is why, despite his advocacy of 'impersonality', the collage of quotations in Eliot's *The Waste Land* can be seen as sexual confession, rather like the extraordinary range of deformations that Picasso inflicts on the bodies of women).

'If the subjects I have wanted to express have suggested different ways of expression I have never hesitated to adopt them', said Picasso. This modernist choice of styles is not a sign of instability,

but an aspect of freedom. Diversity of style is liberal democracy in art – and, as we shall see, it was the Soviet and Nazi dictatorships that demanded an explicitly anti-modernist reversion to an official unity of realist style in the arts.

Technique and idea

But the question then inevitably arises, what was all this technical experiment for? What points was it trying to make? For the three works looked at above, part of the answer would involve cultural comparison, the clashing simultaneity of modern urban experience, and the critical distance enabled by parody. If we can answer such questions, we are well on the way to understanding modernist art. In particular, we need to know how these technical changes were driven by new ideas, or changes in an artist's conceptual scheme, of a revolutionary kind. The artist is sustained in the making of formal discoveries by the expectation that they will be significant in relation to a particular content. That is, they will lead to a cognitive gain, because the technical and experimental development we see in modernist work nearly always arises out of profound shifts in the intellectual assumptions of artists. It is the ideas in the heads of men and women, such as those concerning the self, myth, the unconscious, and sexual identity, which the modernists took from authorities like Friedrich Nietzsche, Henri Bergson, Filippo Tommaso Marinetti, James Frazer, Sigmund Freud, Carl Jung, Albert Einstein, and others, that make cultural revolutions. The idea – of making cross-cultural allusions, or of looking for a quasi-scientific analytical pattern – prompts a change in artistic technique. These breakthroughs are by definition 'progressive', because once you can master the technique (or, more feebly, imitate it, as minor cubists like Albert Gleizes and Jean Metzinger did), you can do something that you couldn't do before.

The most influential modernist works thus provided paradigm procedures which could then be used for often quite divergent purposes, as part of a generally progressive modernist movement,

oriented towards the 'new'. So *La Ville* develops the paradigm of cubism, and the idea that the city, like a daily newspaper (as the futurist Marinetti pointed out), is the site of simultaneous happenings which we can only juxtapose with one another. And Virginia Woolf, who did not much approve of the moral tone of *Ulysses*, nevertheless prolongs its paradigm in her *Mrs Dalloway* (1927), which also follows the stream of consciousness of her central characters through twenty-four hours of life in a major city, uses central topological and temporal points to orient the characters and the reader (Joyce's Nelson Column becomes Big Ben in Woolf), and bases her plot on the long-deferred mental encounter of two antithetical, older and younger persons.

To understand an innovation, then, we need to understand the intellectual model that the artist or scientist is using. We can ask whether Marcel Proust or T. S. Eliot, or James Joyce or Virginia Woolf, made Bergsonian assumptions about memory and the nature of the mind or the self, or ask how 'Freudian' Richard Strauss was in *Elektra* or Arnold Schoenberg in *Erwartung*. However, to convey historical conviction, that is, any sense of his or her own critical contemporaneity as making a difference, the innovative artist also needs to be supported by evidence for the diffusion of the idea, as inspiring an unsettling analysis of conventional methods and beliefs. And so *The Threepenny Opera*, and the later works of Brecht, offer a new 'estranging' perspective on individual character, and with that, attempt to encourage an anti-capitalist, Marxist perspective on class relations. This sense of an innovatory opposition to what has gone before is essential to the characterization of artistic periods, because it helps us to highlight the changes in dominant states of mind and feeling which were involved, and so in the following chapter I turn to modernist movements, and their relationship to the cultural tradition.

Chapter 2
Modernist movements and cultural tradition

> Eliot's Waste Land is I think the justification of the
> 'movement', of our modern experience, since 1900.
>
> > Ezra Pound, letter to Felix Schelling, July 1922

> The artistic climate here cannot support anything that is not
> the latest, the most modern, up-to-the-minute, Dadaism,
> circus, variété, jazz, hectic pace, movies, America, airplanes,
> the automobile. These are the terms in which people here
> think.
>
> > Oskar Schlemmer in 1925 on the Bauhaus move from
> > Weimar to Dessau

Modernist cooperation

In all periods, great artists tend to know one another: and their
cooperation (or rivalry, as in the case of Pablo Picasso and Henri
Matisse) comes from a sense of 'what is going on'. This sense can
far exceed that of any manifesto-bound artistic movement. Claude
Debussy was perhaps the first person to hear the *Rite of Spring*, by
sitting down at the piano to play it through with its composer, who
was also the friend of Maurice Ravel, Erik Satie, Jean Cocteau,
André Gide, Paul Claudel and Paul Valéry, Pablo Picasso, Fernand
Léger, and André Derain. Picasso, like Stravinsky, was well

acquainted with the Parisian avant-garde in all the arts, hence his witty design for the cover of Stravinsky's *Ragtime*, which came about through Blaise Cendrars' recommendation to the *Editions de la Sirène*, and his designs for Sergei Diaghilev's production of Satie's *Parade*. There is often a good deal more to be learned about the progress of art from biography than there is from manifestos or the propaganda of critics. It is the practical, spectacle-producing interactions between Stravinsky, Ravel, Satie, Léon Bakst, Alexandre Benois, Matisse, Picasso, Cocteau, and Gide, and many others within Diaghilev's Ballets Russes, which led to such obviously avant-gardist works as the *Rite* and *Parade*, as well as to work more traditional in conception but still stylishly modernist, like *Carnival*, based on Schumann, or Francis Poulenc's *Les Biches*. The Ballets Russes was a leading modernist grouping, not least because Diaghilev was uniquely able to get avant-garde artists to work together.

It is this kind of cooperation between artists, like that of the Brücke group of expressionist painters (Ernst Ludwig Kirchner, Erich Heckel, Max Pechstein, and others), or of Schoenberg and Alban Berg and Anton Webern, all working intimately together, which gave to them, and to us, the sense of a 'modernist movement' as a general tendency of the time, as when Pound and Eliot read the early episodes of Joyce's *Ulysses* in typescript, realized that parallels between past and present could be made possible by allusion – and then wrote the early *Cantos* and 'Gerontion' and *The Waste Land*. Eliot's 'Tradition and the Individual Talent' (1919), with its advocacy of an awareness in the author that 'the whole of the literature of Europe from Homer and within it the whole of the literature of his own country has a simultaneous existence and composes a simultaneous order', can be read as a rationalization of the work of all three writers at this time. Nevertheless, it is often up to us to infer artistic intentions, because the great modernists didn't always explain themselves or write manifestos. Picasso and Braque invented cubism without saying a single explanatory word about it. They just watched and discussed each others' studio

practice, and we can only infer their 'progress' in 1907–15 from 'analytic' cubism, which is primarily concerned with a rather craggy geometrical deformation of the object from many points of view, in a kind of monochrome with very few clues to local colour (so that a portrait head can look rather like a rocky landscape), towards a more accommodating 'synthetic' cubism, which uses much more colour and flatter geometrical shapes, and can look like collaged elements on the surface of the canvas.

Even the more self-consciously and politically-arousing forms of artistic provocation, such as the many 'Futurist Manifestos' (on painting, music, lust, and so on) are often no more than *ad hoc* alliances of art and idea. The futurists and Dadaists were typical, on the other hand, of those who preferred to work within a declamatory theoretical orientation, which claimed to be 'avant-garde' through the diffusion of revolutionary ideas. Other manifesto developments were more technically oriented, and so Pound gets F. S. Flint to write a manifesto for Imagist poetry which advocates 'direct treatment of the "thing", whether subjective or objective', composition 'in the sequence of the musical phrase', and so on.

Notions of progress – art and abstraction

Ideas like these were immensely important for modernism as an art movement engaged in a period of great intellectual change. And so it is hardly surprising that ideas about the 'necessary' evolution of art became an important part of the movement in general. This meant that critical explanation was as much needed as manifesto. A good example of the kind of modernist change that needed explanation is the growth of abstraction in painting, which involved the destruction of the conventions of 19th-century realism, to make a modernist art which denied any such aims at a subservient, even if virtuosic, transparency to the world. It therefore insisted on the spectator's awareness of the artwork's own conventions, and so brought about a much more obliquely suggestive relation of work to world.

There were two essential developments. The first, as we have already noted, was the emancipation of painting from the representation of 'true' local colour, which allowed pure colour to create its own emotional effects, as in later Van Gogh, and the work of Matisse. This was particularly crucial for Kandinsky, for whom:

> Vermilion attracts and irritates like a flame upon which a man fastens his hungry gaze. A bright lemon-yellow produces pain after a while, just as the high notes of a trumpet pain the ear. The eye grows excited, it cannot withstand the effect for very long and seeks a deep peace in blue or green.

Along with this went an even more influential development: a growing sense of the value of the simplification of the object in drawing. Desmond McCarthy explains this in his preface to the 1910 catalogue of the London Post-Impressionist exhibition, by using a musical metaphor (which nearly always also suggests that painting, like music, has its 'own' language). He says that:

> this search for an abstract harmony of line, for rhythm, has been carried to lengths which often deprive the figure of all appearance of nature. The general effect of his [Matisse's] pictures is that of a return to primitive, even perhaps of a return of barbaric, art... Primitive art, like the art of children, consists not so much in an attempt to represent what the eye perceives, as to put a line round a mental conception of the object.

Both of these methods strike a blow for the autonomy of the work of art, because of the way in which we are forced to consider the work on its own terms, and not just as a mirror onto reality. Colour, once emancipated from local representation, can be 'harmonized', as Matisse argues, to make a musical effect:

> From the relationship I have found in all the tones there must result a living harmony of colours, a harmony analogous to that of a musical composition.

Roger Fry confronted the conservative public on these issues, and attempted to explain the merits of the new art in the second Post-Impressionist exhibition of 1912, by introducing a new critical vocabulary:

> Now, these artists do not seek to give what can, after all, be but a pale reflex of actual appearance, but to arouse the conviction of a new and definite reality. They do not seek to imitate form, but to create form; not to imitate life, but to find an equivalent for life. By that I mean that they wish to make images which by the clearness of their logical structure, and by their closely-knit unity of texture, shall appeal to our disinterested and contemplative imagination with something of the same vividness as the things of actual life appeal to our practical activities. In fact, they aim not at illusion but at reality.

This emphasizes our contemplation of the work of art as such, and is crucial: we experience 'that decorative unity of design which distinguishes all the artists of this school'. Matisse, in particular, 'aims at convincing us of his forms by the continuity and flow of his rhythmic line, by the logic of his space relations, and above all, by an entirely new use of colour'.

We can see some of this in a wonderful image, *La Conversation* [*The Conversation*] of 1909–12 which was shown at the second Post-Impressionist exhibition in London in 1912 (reproduced in Illustration 3). The colour harmonies of this painting, in blue and in red and green, are very striking. There is a strong emotional contrast between the colours used for the room and the garden: a cold blue and black within, and a warm green and red outside. And the shapes for the tree and flowerbed echo those of the couple in conversation. But it is hardly communicative – the figures of Matisse and his wife Amélie are hieratic and stiff; they are based on a stele of Hammurabi before the seated goddess Shamash, which Matisse had seen in the Louvre. Amélie seems to be laying down the law, and her answer may well be the 'NON' we can see in the ironwork of the balcony. But it is the simplification of the figures,

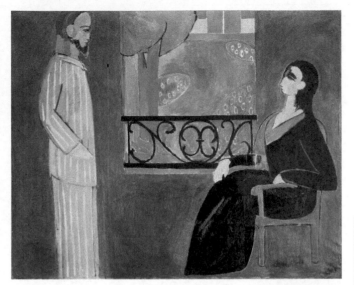

3. Henri Matisse, *La Conversation* (1909–12). An immensely sophisticated abstraction in drawing, which originally seemed merely childish

the sense of a designed balance, and the lack of interest in local detail, which counts for this painting's claim to the abstraction described by Fry and his colleagues. And as he points out:

> The logical extreme of such a method would undoubtedly be the attempt to give up all resemblance to natural form, and to create a purely abstract language of form – a visual music; and the later works of Picasso show this clearly enough.

Fry had seen only some early Kandinsky in London in this period, but his prediction concerning a progressive abstraction, made on the assumption that the effects of abstract painting can be more and more like those of music, is confirmed by the way in which the apocalyptic symbolism of the castles and towers and spears and boats in early Kandinsky become more and more difficult to

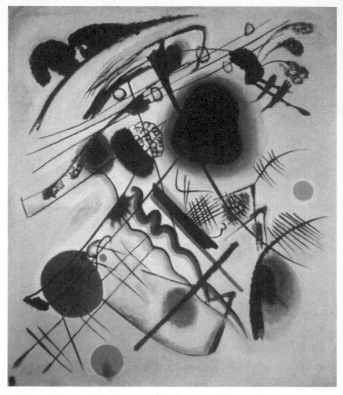

4. Wassily Kandinsky, *Der Schwarze Fleck* (1921). A biomorphic abstraction here moves away from naturalistic depiction towards imaginary objects

discern. The picture reproduced here (Illustration 4) is from the period 1915–21, when he moved towards forms of pure biomorphic and then (at the Bauhaus) geometric abstraction. In *Schwarzer Fleck* [*Black Spot*], I can see a possible serpent, maybe a boat and oars, in its frequent position for Kandinsky, at the lower left, and maybe bits of the outline of his frequent motif of a reclining couple, just above the 'boat'. But this may be fanciful: it is the colours and

the dynamism of the relationships between shapes which are important here. Looking at the pictures of this period, Jelena Hall-Koch finds it as difficult as I do to answer the question, 'When in fact did Kandinsky begin to introduce new, completely free visual elements bearing no resemblance to natural or any other type of familiar objects into his pictures?' But there is no doubt that the ultimate aim is a greater abstraction. We can see this at its most impressive in the amazing sequence of ten 'Compositions' made by Kandinsky from 1910 to 1939.

Ideas about abstraction recur in all the languages of Europe, in attempting to show that modernist artists worked 'progressively' on the renunciation of photographic resemblance, as if the aim was, by a steady subtraction, to become more and more 'abstract', but, as we have seen, in very divergent ways (Piet Mondrian regretted that Picasso never quite got there).

New languages for the arts

This kind of modernist advance is explained as a development and modification of what went before – so that links to an earlier and more intelligible art can be made obvious. But those artists who changed the very language of art were the more obviously radical. The heroic figures of the early modernist period – Picasso, Joyce, Kandinsky, Schoenberg, Stravinsky, Pound, Eliot, Apollinaire, Marinetti – all did this for their respective arts. Picasso, with the *Demoiselles d'Avignon* (1907), with its anguished, edgy, ugly nudes, some of their faces like Iberian masks, others deformed like those of syphilitics. Joyce, with the opening pages of *A Portrait of the Artist* (1914), which are an extraordinary rendition of the visual experience and stream of consciousness of a young child. Schoenberg, with the last movement of his *Second String Quartet* (1908), in which the voice he has added steadily floats upward into the 'new air' of a music without tonal points of reference. Stravinsky, with the *Rite of Spring* (1913), with its primitive savagery, then apparent cacophony, unprecedented

shifts in rhythm, and final climactic stampede in the 'Dance of the Earth', in which a sacrificial virgin dances herself to death.

The alogical free associations of poets like Apollinaire, Cendrars, Pound, Eliot, Gottfried Benn, Jakob van Hoddis, August Stramm, and others also challenged the very language of rational order, and its implications for social conformity. 'Let us go', says Eliot's Prufrock, and we set off through the sordid streets of Boston, which, like the poem itself, perhaps lead towards an 'overwhelming question'. But in a poem that contains at least fifteen questions, it is difficult to decide which is the overwhelming one, since they all seem to cause Prufrock embarrassment. The innovatory point of this poem doesn't just depend on its astonishing range of allusion, to Dante, Laforgue, Hesiod, Ecclesiastes, Marvell, John the Baptist, and others, and its stylistic parodies of Shakespeare and Swinburne, amongst many others, but on the unprecedented work that it still makes us do, across its many white spaces, which are also conceptual gaps, between paragraphs which follow an associative rather than a narrative logic and don't even have a psychologically coherent order. Is Prufrock really confronting the mysteries of the universe, or is he just a deeply literary, fantasizing man who funks going to a tea party to proposition an attractive woman? As with so much modernist art, it is the reader or spectator or listener who has to work out the relevance of one fragment to the next and then to its successors, in the process tracing and learning a logic which is very different indeed from that of the art which came before, and which remains challenging after a hundred years.

For some artists, this pursuit of a radically new and wholly uncompromising way of ordering a work of art was basic to their conception of their task: for example, those who followed Schoenberg beyond the progressive atonality of his *Second Quartet* and *Pierrot Lunaire* into developing new conventions for twelve-tone music. Schoenberg indeed shows particularly well the way in which those avant-gardists who aimed at a radical change of paradigm also wanted to be written into a progressive *history of art*. He therefore

attacks those past 'laws' or 'codes' which he saw (with some exaggeration) as having 'legislated' for German music, but then came up with some of his own, telling his pupil Josef Rufer in the summer of 1921 that he had 'made a discovery thanks to which the supremacy of German music is assured for the next 100 years'. The characteristics of his new 'twelve-tone' system were first explained to the world in his disciple Erwin Stein's essay *'Neue Formprinzipien'* in 1924. Put very crudely, the musical movement of a work has to be built from a single 'row' of notes, the 'basic set', which uses all twelve tones of the chromatic scale, in a fixed order that remains unaltered throughout the piece. The series can be put into inversion, retrograde, or retrograde inversion, and start at any one of the twelve notes. (This means that the composer has forty-eight tone-rows available for any piece, but the scheme nevertheless involves an amazing number of restrictions.)

Schoenberg's *Wind Quintet*, Op. 26 of 1924, was the first long piece to be composed entirely according to this method. (And it is this work that Stravinsky studies so closely in 1952, years later, in his own 'conversion' to a quasi-serial method of composition.) Twelve-tone music can look very like a modular mode of geometrical construction – with a set of rules to follow, which might well eliminate any kind of personal expressiveness – and the justification for the procedure was, for Schoenberg, impersonally scientific: he claimed that his experiments had revealed the true nature of sound-relationships, by the discovery of 'non-Pythagorean' combinations of tones. Amazingly enough, by 23 July 1925, Alban Berg had written his *Chamber Concerto*, which is a highly systematic, discipular work and carried atonal and twelve-tone writing to intricate and indeed number-symbolic lengths. It is not, however, the detail of the twelve-tone *method* which matters so much, as the peculiar mixture of avant-gardist *ideas* about its philosophic and quasi-scientific necessity that Schoenberg and his interpreters, notably Theodor W. Adorno, came to attribute to the method.

There is therefore often a kind of 'false scientism' in much modernist activity – an attitude to the modern world which demands that the arts use rational compositional methods, so that we get down to a more fundamental level of reality, which is often fantasized to be common to art and science (and indeed to the cosmos as a whole). Piet Mondrian and his followers in the movement of De Stijl made these sorts of claims, and complicated matters by adding to them a metaphysical layer of mystical theology. When we look at Mondrian's paintings of the period 1917–21, we see work which seems to have no mimetic subject matter, except itself, because it belongs to a modernist tradition which had strongly theoretical views about the use of a restricted, rule-governed language of straight lines and rectangular colour planes. It produced an abstract art which was 'purified' compared to that of others, but also (in a way that is prophetic for later geometric abstraction) results in an immediately recognizable style. For example, the *Composition with Red, Yellow, Blue and Black* of 1921 (Illustration 5) has a 'dynamic balance of opposing forces' in which there are 'narrow marginal planes' along with a great red square, which 'dominates' the rest of the area, allowing for a 'variety of spatial and proportional readings', as 'the large red' is 'answered by a multitude of small planes with a cumulative supporting role'.

There is an extraordinary pseudo-philosophical vagueness in Mondrian's writings about art like this, because his formulae for composition, and for the expected effect of his paintings, both fall under the same very general concepts, such as 'universality' or 'equilibrated colour relationship'. His paintings seem to deny individual expression, for 'only when the individual no longer stands in the way can universality be purely manifested'. The aim is at harmony within the work, so that: 'The *rhythm* of relationship of colour and dimension (in determinate *proportion and equilibrium*) permits the absolute to appear within the relativity of time and space.' Our enjoyment of Mondrian (if not our philosophic admiration of him) depends on our feel for harmony

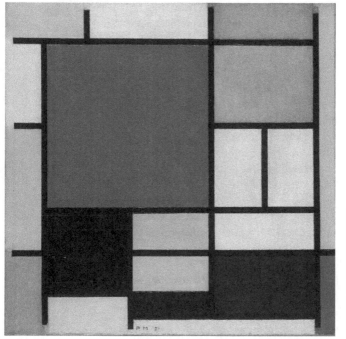

5. Piet Mondrian, *Composition with Red, Yellow, Blue and Black* (1921). Balance and harmony in a mathematical organization

and balance, and an intuitive feeling that the proportions of the picture are irregularly interesting. (This balance ought to be boring, but as Waddington has shown, the proportions of Mondrian's paintings do not fall into any very obvious mathematical ratios.)

Mondrian is a good neo-Platonist as well as a 'Neoplasticist' in painting, and with him we see a significant beginning to the demand for the understanding of art as the exemplar of the

hypostastized concepts of a theory (which has had a long run, through to the conceptual art of the postmodernist period). For he was driven to find a language within painting which would follow his religious and philosophical convictions about simplicity (beyond any symbolic significance or reminiscence of real-life objects, such as are to be found in his earlier work).

The philosophy drives the painting. This is a motivation common to the artists of De Stijl and to others in this period, who were following the dream of a simple, unambiguous, uncompromised, adequate language, beyond the pragmatic ambiguities of everyday life. As Schoenberg and others rewrote the previously accepted tonal grammar of music, so Mondrian and his colleagues sought a syntax for painting that would be independent of local mimesis, and yet, like Schoenberg's music, close to a 'more fundamental reality'. It is very difficult to see in this kind of work anything to cause the effects that are claimed for it. It may function as an ikon, by reminding its followers of a theosophical religious belief, but its effects are largely contemplative, and so transformative of the individual. As harmonious designs, rather than as religious symbols, works like this can give great pleasure.

Modernism and art movements

Were the artists discussed above part of '*the* modernist movement'? Not if that implies a single centrally agreed set of ideas, like those of a political party, even though some of them, as I have suggested, achieved a very wide diffusion. Given the pluralism and dissent that characterizes this period, we can see that modernist avant-garde groups – Vorticist, Imagist, the Second Viennese School, De Stijl, Dada, surrealist, and so on – brought about a serious generational change. And when groups of the more or less like-minded got together, as in the Vorticist movement, we can see that Pound and Eliot and Joyce and Lewis, and others, like Hulme and Flint, who were in intimate contact with them, made a temporary common cause, in a 'movement', through which a collective self-

consciousness is most obviously, yet often mendaciously, made apparent by a manifesto by one of them, as in Wyndham Lewis's two issues of *Blast* in London, thus, he thought, bringing about a 'great modern revolution', in all the arts, against the 'weeping whiskers' and 'fraternizing with monkeys' of the Victorians. For him, and for Pound, it was the end of the Christian era.

The same self-consciousness affects Kandinsky and Schoenberg from 1909 to 1914, and also the other members of the Blaue Reiter group (including August Macke, Franz Marc, and Gabrielle Münter). Their *Almanack* of 1912 is evidence for a similar change of ideas in Munich. This means that long before the rise of 'theory', much modernist art is to be understood through the quasi-philosophical, theological, and psychological speculation which helped to inspire it, for example in work like Kandinsky's *On the Spiritual in Art* (1912), W. B. Yeats's *A Vision* (1925), and the writings of the De Stijl group.

As we shall see, some avant-garde groups adopted methodologies which pursued more obviously immediate political ends, notably in the early German expressionist and futurist movements, Dada in Germany after 1918, and in the programmes of the Bauhaus, which were deeply concerned with modernity and particularly with the place of technology in society. For it is the architecture of the period which stays with us, and defines a past period; the then newly invented Bauhaus architecture, furniture design, and printing conventions are still with us today. In particular, they were concerned with the changing relationships between man and machine. As Moholy-Nagy puts it, in an essay called 'Constructivism and the Proletariat' (May 1922):

> The reality of our century is technology: the invention, construction and maintenance of machines. To be a user of machines is to be of the spirit of this century. It has replaced the transcendental spiritualism of past eras.

And he continues:

> Everyone is equal before the machine, I can use it, so can you. It can
> crush me; the same can happen to you. There is no tradition in
> technology, no class-consciousness. Everyone can be the machine's
> master or its slave.

Such utopian programmes were often intended to be democratic
and egalitarian, though were rarely so in effect, as Charlie
Chaplin's *Modern Times* (1936) demonstrated to huge audiences
throughout Europe and America.

A similarly comic and yet threatening approach to the machine
was also taken by Francis Picabia and Marcel Duchamp, in
particular in the periods when they were together in New York,
between 1915 and 1917, spreading Dada-like ideas and becoming
immensely influential on the development of modernism in
America. Picabia's *Prostitution Universelle* of 1916 (Illustration 6),
one of a number of similarly themed works, takes the bodily,
sensual response away from a depiction of woman as a machine,
and with a good deal of misogyny implied. At this time, Picabia
proclaimed that 'the genius of the modern world is
machinery.... really a part of human life – perhaps the very soul'.
One can appreciate the metaphors of energy and technology
involved in this and in Picabia's depiction of a *Young American
Girl* as a sparking plug – she is primarily a modern object,
controlled by men (as in the e. e. cummings poem 'she being brand
new', where male control in intercourse is compared to the driving
of a car). A very complex development of this early, playfully
anarchist and Dada-inspired allegory for sex and the modernity
of the machine is to be found in Duchamp's famous *Large Glass*
(1915–23) and the works leading up to it.

It is the general diffusion of ideas through the critical
interpretation of the time (as in the work of Fry and Bell cited
above), rather than the rhetoric of manifestos, which brings us

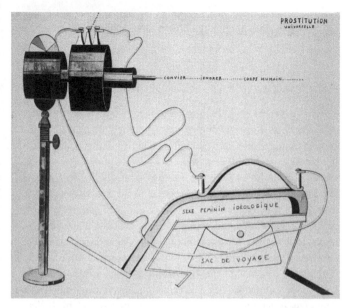

6. Francis Picabia, *Prostitution Universelle* (1916). Human beings as seen within the machine age

most closely to the changes in thought and sensibility that the experience of new works of art can bring about. It was the responses of many writers, like those of Vauxcelles and Apollinaire to early cubism, which extended the reception of the artists' new language – by inventing discourses which approximated to the particularities of the technique involved. There is therefore a gap between our awareness of the innovatory intentionality of Braque and Picasso in 1910–11, and the later extrapolating interpretations of their work, which helped to create the notion of a cubist avant-garde, for example in the work of Gleizes and Metzinger and propaganda for the *Section d'Or* exhibition by 1912.

It is through this kind of reception that artists in all media became aware of a European movement, which wanted to 'make it new' and thought of itself as 'modern', or modernist.

Neoclassicism

There is nevertheless a distinction to be made between this kind of self-conscious avant-gardist change in the language of art, and a perhaps simpler and more socially accommodating desire to 'make it new'. Many artists did not want to be seen as somehow bound up, for good or ill, into someone else's propagandistic discernment of 'reactionary' and 'progressive' tendencies. Stravinsky is a notorious example of this. He produced some of the 20th century's most revolutionary works, and yet never belonged to a modernist movement of the kind mentioned above. Nevertheless, it was surprising that after his experimental and confrontational ballets, notably the *Rite* (1913) and *Les Noces* (1914–17, orch. 1923), he took to making works like *Pulcinella* (1919–20), in a much easier language; indeed in a neoclassical, pastiching style. This ballet, with songs from the orchestra pit, derived from an orchestration and very partial recomposition of works originally attributed to Pergolesi, and had costume designs by Picasso. It was classical, clear, not at all Russian, French rather than Germanic, and so came perilously close to the mere pastiche of other ballets of this period, such as Respighi-Rossini's *La Boutique Fantasque* (1919) and Tommasini-Scarlatti's *The Good Humoured Ladies* (1917), which were also spiced-up arrangements of previous music.

Stravinsky thought that *Pulcinella* was another revolutionary work, in its juxtaposition of orchestral timbres as if they were colour contrasts (for example, in the wonderfully jazzy duet between trombone and double bass). But the work was too charming to seem experimental, and the combination of graceful melody and Picasso's neoclassical-and-cubist commedia dell'arte figures made the work (thanks again to Diaghilev) seriously fashionable. By 1934, Constant Lambert could complain that 'a

composer with no creative urge and no sense of style can take medieval words, set them in the style of Bellini, add 20th-century harmony, develop both in the sequential and formal manner of the 18th century, and finally score the whole thing for jazz band'. But Stravinsky was not that kind of composer; and the great neoclassical ballets which succeeded to *Pulcinella*, from *Apollo* to the partly twelve-tone *Agon*, are now central to the repertory of modern ballet, thanks to the genius of their choreography by Georges Balanchine.

Stravinsky was accused by the Schoenberg party of reactionary regression, and a failure to grasp the internal dialectic of a truly progressive artistic development for the language of art:

> 'No, no,' protested Stravinsky. 'My music is not modern music nor is it music of the future. It is the music of today. One can't live in yesterday nor tomorrow.'
>
> 'But who are the modernists then?'
>
> Stravinsky smiled. 'I shan't mention any names,' said he, 'but they are the gentlemen who work with formulas instead of ideas. They have done that so much they have badly compromised that word "modern." I don't like it. They started out by trying to write so as to shock the Bourgeoisie and finished up by pleasing the Bolsheviki.'

Schoenberg knew of this interview, and wrote a reply in his 'Igor Stravinsky: Der Restaurateur' dated 24 July 1926. Its first line is: 'Stravinsky pokes fun at Musicians who are anxious (unlike himself, he wants simply to write the music of today) to write the music of the future.' Here are two great composers (and their followers) battling for long-term influence: Schoenberg is sanctified as progressive and Stravinsky vilified (by Adorno, as late as 1948) for having fallen into a state of 'infantile' regression which led to neoclassical pastiche.

This difference, between being part of a more or less organized movement and the merely 'contemporary' exploitation of a popular or fashionable style, becomes more and more important as modernist

31

developments are more and more politicized. For Adorno, Schoenberg is obeying the inner laws of history, as seen by a Marxist: as he puts it in the 'Schoenberg and Progress' section of his *Philosophy of Modern Music*:

> The rules [sc. of twelve-tone music] are not arbitrarily designed. They are configurations of the historical force present in the material. At the same time, these rules are formulae by which they adjust themselves to this force. In them consciousness undertakes to purify music of the decayed organic residue. [sc. of earlier styles] These rules fiercely wage battle against musical illusion.

This is Marxist theory written into aesthetics, with its perception of an inner dialectic of history, and its challenge to the 'false consciousness' of the individualistic bourgeoisie, which is embodied in the hitherto accepted musical tradition.

But the turn to the art of the past in the 1920s did not look like that to its participants. For these allusive assertions of continuity took on a distinctively modernist, parodic, and ironic mode, which engaged directly and critically with the social assumptions of its audience. It was all the more affronting, in that it succeeded a pre-war period of intensely serious formal experiment. As Paul Dermé suggested, 'A period of exuberance and force must be followed by a period of organization, stocktaking, and science, that's to say a classicist age', and Pierre Reverdy thought that 'fantasy gave way to a greater need for structure'. This reappraisal of the artist's relationship to the past opened up an aesthetic of stylistic self-consciousness and hence an acute awareness of the contrast between modernity and the past. '*Pulcinella* was my discovery of the past, the epiphany through which the whole of my late work became possible', said Stravinsky. The work is to be seen in relation to the history of art, and the technique allowed for the irony which is a leading characteristic of high modernist art: 'The convention is preserved: the characteristics of waltz, galop, or march are reduced to type-models, deliberately exaggerated and

given an ironical note, so that the social prototype is revealed by means of caricature', and not just in the work of Stravinsky, but in that of Les Six, Prokofiev, Shostakovitch, Ravel, and many others. But it also allows, in more serious work like Stravinsky's *Octet*, which goes back to Bachian counterpoint, for a deeper sense of tradition. Stravinsky thought of it in terms borrowed from painting, as a spatial object akin to geometrical abstraction: 'My *Octuor* is not an "emotive" work but a musical composition based on objective elements which are sufficient in themselves.... an object that has its own form. Like all other objects it has weight and occupies a place in space.' As Messing remarks:

> In this work, Stravinsky appears in the light of the constructivist, of geometry; all of his thought is translated into precise, simple, and classic lines; and the sovereign certainty of his writing, always renewed, here takes on in its dryness and precision an authority without artifice.

This stylistic pluralism, and the accessibility brought about in some cases by simplification, is typical of the post-war period, in which modernist styles become fashionable, and it marks a great increase in works of art that depend on this historical canonic allusiveness. All this was part of a post-war 'call to order' in the arts (which was also associated, for many more minor artists, with a generally conservative recall to patriotic and nationalist forms of order in politics). Modernists of all kinds turned themselves to the adaptation of past works, to stylistic eclecticism, to parody, to neoclassic revivalism, and so on.

For example, Léger's *Le Grand Déjeuner* [*Breakfast, Large Version*] (Illustration 7) moves away from the simultaneist celebration of modernity in *La Ville* towards a mechanized version of neoclassicism. These are 'odalisques', and so remind us of the neoclassical painter Jean Auguste Dominique Ingres; the shiny grey skin-tone looks polished and sculptural, recalling the heroic, stoic spectacle of David; and in the swelling up of the women's bodies, it

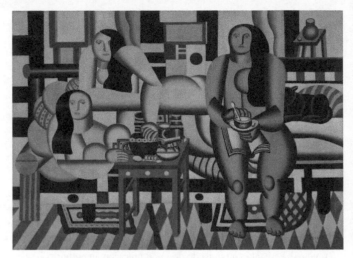

7. Fernand Léger, *Le Grand Déjeuner* (1920–1). A cubist monumentality which leaves little room for the eroticism of previous depictions of the nude

recalls the classical style of Nicolas Poussin, in a manner similar to Picasso's neoclassical works of the time, such as *Trois femmes à la fontaine* [*Three Women at the Spring*] (1921) (Illustration 8). Picasso even made a Renaissance-inspired red chalk cartoon study for this very sculptural image, which alludes to Poussin's *Eliezer and Rebecca at the Well* (1648). But what it most resembles is Greek funerary sculpture, and the tone of the picture is certainly sad and restrained, which is paradoxical, because the subject usually connotes the celebration of fertility. Elizabeth Cowling suggests that the picture may be an act of post-war mourning.

This art was never merely dismissive or parodic: and that again is the difference between the neoclassicists and the postmoderns. Neoclassicism in the arts appealed to the ideas of the abstract, absolute, architectural, pure, concise, direct, and objective, and marked a return to a belief in the 'universal' language of art, rather than in the radical invention of new ones.

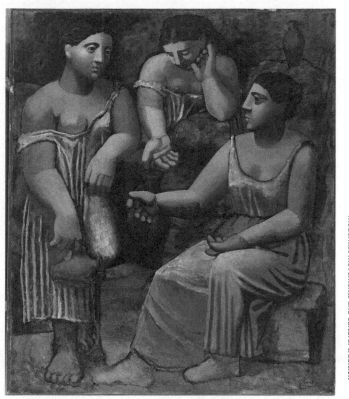

8. Pablo Picasso, *Trois Femmes à la Fontaine* (1921). Women as statues: neoclassicism in competition with its predecessors

Picasso's move to an overtly mimetic neoclassical style also looked to some like an abandonment of avant-gardist experimentation. (He was also interested in imitating Ingres, in his portrait of Madame Wildenstein, for example.) John Berger later argued that such works:

> are not as satisfying or as profound as the originals because there is a self-conscious division between their form and content. The way in which they are painted or drawn does not come out of what Picasso

35

has to say about his subject, but instead out of what Picasso has to say about art history … [he] gives Madame Wildenstein the mask of an Ingres, he could have given her the mask of a Lautrec, but it would have been socially undesirable.

Tradition

The work of Ezra Pound and T. S. Eliot is clearly 'European' … The 'European' poet is acutely aware of the social world in which he lives, he criticizes it, but in a satirical rather than in an indignant manner, he adjusts himself to it, he is interested in its accumulated store of music, painting, sculpture, and even in its bric-a-brac. If the poet is in the 'European' tradition, he describes the elements of civilisation wherever he finds them: in Rome, in Greece, in Confucius, or in the Church of the Middle Ages; and against these he contrasts the violence and disorder of contemporary Life.

Modernists took a very broad view of the culture in which they found themselves. Eliot's demand for an 'historical sense' still has room for Marie Lloyd and 'that Shakespeherian rag' in *The Waste Land*. Nevertheless, if you read the first section of the poem alone, you will have to know at least some Chaucer, Shakespeare, Wagner, Old Testament, Greek and 'vegetation' myth, Baudelaire, and so on. Indeed, as Eliot put it in his 'Tradition and the Individual Talent', 'not only the best, but the most individual parts of [a poet's] work may be those in which the dead poets, his ancestors, assert their immortality most vigorously', because avant-gardist originality here comes from the way in which Eliot's selection from the canon of European literature, as he sees it, is used to make a complex point about the relationship of cultures across time. This willingness to adapt the works of the past is common to Joyce, Picasso, Stravinsky, Berg, Schoenberg, Thomas Mann, and many others. For Stravinsky, tradition 'results from a conscious and considered acceptance … A method is replaced: [whereas] a tradition is carried forward in order to produce something new. Tradition then asserts the continuity of creation.' Modernists of the 20th century were consciously reflective

about the relationship and contrast of their work to that of the past, with which they competed. It is soaked in history, and it works by a repetition of themes (which gives it universalism) and a simultaneous contrast to the past (which very often imparts a relativist irony). Nevertheless, the imitation of a Bach Chorale in *The Threepenny Opera*, which suggests the decline of religion into popular and insincere sentiment, is very different from the quotation of the Bach Chorale '*Es ist genug*', from *Ewigkeit, du Donnerwort*, which makes an unbearably elegiac climax for Berg's *Violin Concerto*. Both composers give a depth of meaning to their work by expecting it to be recognized, so that something from the original textual context can be an emotional implication of the modern work. Such effects go far beyond mere pastiche, because they are not just stylistic deviations, but arouse a sense of the generally non-nostalgic availability of works from the past as touchstones for our feelings in the present.

These appropriations brought much of modernism within a self-consciously European movement. Pound, Eliot, and Joyce (that is, two Americans and an Irishman) believed in the 'mind of Europe' – to which for them the ideas of Henrik Ibsen, Nietzsche, Bergson, Freud, Einstein, Marinetti, and others had made vital contributions. All the major modernists were acutely aware of other languages and other cultures, even when they were also deeply involved with nationalist concerns (like Yeats, who had an absorbing interest in Indian and Japanese cultures as well as Celtic ones). The range of reading of Yeats, Mann, Gide, Joyce, Stravinsky, for example, was amazingly wide. Picasso's references to painting, and Schoenberg and Berg's to the music of the past, was similarly encyclopaedic, and their work is as complex as that of Eliot and Joyce in this respect.

But there are no major modernists in Europe whose work was not also significantly inspired by non-European national cultures, including aspects of non-Western cultures in many cases, as in Mahler's in *Das Lied von der Erde*, Yeats's Noh plays and late poetry, Pound's *Cathay*, Brecht's *The Good Woman of Sezuan* and

The Caucasian Chalk Circle, and Hesse's *Siddhartha*. And German expressionist painters, the early Picasso, Darius Milhaud, Stravinsky, and D. H. Lawrence were among the many modernists who were interested in what they thought of as 'primitive' cultures, mostly African, and in adapting them within European art.

The development of experimental or advanced art in America also depended very largely (in the earlier period) on an absorption of European culture – very obviously so in the cases of Wallace Stevens, e. e. cummings, and the early William Carlos Williams, who were all Francophile.

Williams and Stevens are of particular interest in this respect because of their knowledge of post-cubist painting, notably as displayed in New York in the famous Armory Show of 1913. As Williams put it:

> In Paris, painters from Cezanne to Pisarro had been painting their revolutionary canvases for fifty or more years but it was not until I clapped my eyes on Marcel Duchamp's *Nude Descending a Staircase* that I burst out laughing from the relief it brought me! I felt as if an enormous weight had been lifted from my spirit for which I was inordinately grateful.

His abandonment of narrative sequence, for example in *Al Que Quiere*, makes his poems very like pictures. He wanted an effect like that of modern painting, as in the visuality of a poem like 'Metric Figure', and this led him to a concern for the thing or the object (as in Cézanne and the cubists) and hence to the development of dynamic still life in poetry. For him, the poem is, like the work of visual art, an autonomous object with its own shape.

In the introduction to his proto-surrealist *Kora in Hell*, he says that 'the true value is that peculiarity which gives an object a character by itself. The associational or sentimental value is false.' His 'Spring

38

Strains' (in *Al Que Quiere*, probably from late 1916) is an attempt at a cubist painting in words. His fragmentation of sentence and image is obvious in 'The Great Figure', a poem which was interpreted in a painting by Charles Demuth, his 'I saw the Figure 5 in Gold' [1928], which was made in association with Williams. By then, he was searching for the distinctively 'American' subject (along with Stieglitz, Demuth, and Hartley). His idea of the new is firmly based in modernist techniques, but needed an equally unprecedented American subject matter to become independent, in poetry, of the Pound and Eliot Europeanizing tradition. In the prose sections of *Spring and All*, he synthesizes the values of abstraction with his desire to discover the American object (like the photographers and painters in the Stieglitz group) in 'the visual reality of the American scene'. Djikstra points to the 'January Morning' sequence of fifteen poems in *Al Que Quiere*, each with one or two objects closely observed, 'to form a "suite" of essentially photographic images', of which the famous wheelbarrow poem is exemplary.

Wallace Stevens was always 'American' by working in a kind of Emersonian transcendentalist tradition, but also, like Williams, was an associate of the art patrons Walter Arensberg and Carl Van Vechten, and so well aware of avant-garde goings-on in painting, including the famous Duchamp *Nude Descending a Staircase*, which he saw in Arensberg's apartment. His early poems are clearly influenced by similar relativities in visual experience, and he quite famously in his time showed this in his 'Thirteeen Ways of Looking at a Blackbird' [1917]. Stevens's magnificently and always artfully paragraphed free verse was then a more than sufficient sign of avant-gardism. His 'The Man with a Blue Guitar', published in 1937, is a magnificent summation of his view of modernist art, and the philosophy of what we take to be our engagement with the world. It is an extended meditation about modernist artistic re-makings of reality, in verse and painting.

For a rather later writer, like William Faulkner, European modernism was a great part of what he knew – he had read Joyce

and others, and then ferociously applied their stream-of-consciousness techniques. Quentin Compson in *The Sound and the Fury* (1929) is as widely intellectual, as allusive, and as poetically inclined as Prufrock and Stephen Dedalus. He is seen within the very contentious context of the Compson family, and the effects on them all of the post Civil War history of the South. All this is realized in as close a detail as anything in Joyce's Dublin. Along with this goes an immensely complex mythical and symbolic organization. The episodes of *The Sound and the Fury*, for example, parallel the three days of the Christian Easter, and Faulkner constructs here, and in *Absalom, Absalom*, a virtuosic interrelationship between novel plot and the tragic revelation of the historical past from which it emerges. The epistemology of the Faulknerian novel – its relationship to distorted perceptions and relationships, and to an oral tradition of history, is one of the most complex in the modernist tradition, beyond anything in James and Proust. In the process, Faulkner became, like Woolf, one of the most overtly experimental novelists of the 20th century, because, as with Woolf, each of his books (until the late, largely realist Snopes trilogy) is written in an intensely poetic prose, and takes on a wholly individual and significant formal organization: for example, in the psychological cross-purposes and episodic fragmentation of the many interacting streams of consciousness in *As I Lay Dying*.

It was quite late in the day when Williams, for example, came to reject this European dominance and to ask for modernist techniques to be applied to a distinctively American subject matter. But 'purely American' artistic movements of worldwide consequence, which had worked their way beyond European modernist concerns, had to wait until the Second World War; and it was not until the emergence, from surrealist and other beginnings, of abstract expressionism in painting, that a native and independent American art movement achieved an experimental originality and eminence which was clearly indigenous, and of international importance. And it is equally clear that in the

post-Second World War period, American experimental fiction, by Walter Abish, John Barth, Donald Barthelme, Robert Coover, Don De Lillo, William Gass, and others, displayed a greater originality, vitality, and interest than any other contemporary experimental narrative tradition (including the theory-bound French 'new novel').

Nearly all the major modernists saw their work for the most part as coming out of and replying to, and alluding to, earlier traditions of art of which they were acutely aware. Matisse and Picasso, for example, were very capable of painting in earlier styles, and thereby achieving a universality which was broadly neoclassical in inspiration. Until the advent of the Dada and surrealist movements, with their immensely neoromantic emphasis on individual imagination and creativity, the aim for most of them was not just to be 'new', or 'original', or 'experimental', or 'revolutionary', as if one had no predecessors. The earlier modernists thought of tradition, first of all, as an historically defined set of conventions within, and beyond, which they could *work* – as Debussy goes beyond Wagner, and Schoenberg sees his work as building on that of Brahms. Hence too the atonal metamorphoses of the Mahlerian march movement in Webern's *Six Pieces for Orhestra* (1909–10), and Berg's *Three Pieces for Orchestra* (1914–15).

Of course, some modernists were in favour of as complete a rejection of the past as possible. This led to strong claims for originality, which then, as now, were often transmitted at the cost of unintelligibility by the standards of the past, or by a simplistic rejection of them. Marcel Duchamp's rejections, which stem from the emancipatory aims of original Dada, have been particularly influential in this respect. His famous *Fountain* (1917) is a work symbolic of this kind of avant-garde. By buying an ordinary urinal, turning it upside down, and signing it 'R. Mutt', Duchamp tested the spectator's notion of what constituted a sculpture, or 'work of art', and perhaps even more significantly for later developments, he

tested art institutions by asking, in effect, what, in the future, they would be willing to exhibit as (if they were) works of art. This opens up a number of themes that are central to postmodern art.

Cultural diagnosis

Given this set of assumptions, modernist artists and intellectuals saw themselves as serious cultural critics. In England, the prose of Pound, Eliot, Wyndham Lewis, D. H. Lawrence, and Aldous Huxley (and Mann and Gide, and many others elsewhere) most certainly shows this. They tended to be divorced from and marginal to the society in which they lived, following the 19th-century dissenting anti-bourgeois tradition of Flaubert, Ibsen, Wilde, and Freud. Eliot, for example, whose prose is really quite conservative, begins by imitating the absurdly self-deprecating poems of Jules Laforgue, who had shown him the way by laying bare the bourgeois self-deceptions of the age in poetry that was ironic and comic. Hence too, Joyce's advocacy through Stephen Dedalus of a dissentient morality, divorced from conventional political and religious constraints, in *A Portrait*, which is the classic instance for the individual dissenter, who finds a vocation in art, and most particularly in its language, rather than in the social demands of religion, or politics. This is Stephen the student, who is told that his essay on 'Art and Life', devoted to Ibsen, 'represents the total sum of modern unrest and modern freethinking'. Hence also the evolution of Marcel's consciousness in *Á la recherche du temps perdu*, from a naïve acceptance of class assumptions to a detached, subjectivist criticism of them. And many of the major works of this period were based on a concern for the contrast between the high culture of the past and the decline of current social conditions.

One of the most widely read of the books exploring this sort of contrast was Thomas Mann's *The Magic Mountain* (1924), also in essence a Bildungsroman (or novel of educational development) in which the young Hans Castorp is, according to his author:

led in a comical and spine-chilling way through the spiritual antithesis of humanitarian and Romantic attitudes, progress and reaction, health and disease, but more for their intrinsic interest, for the sake of knowing about them, than with a view to decision. The spirit of the whole thing is humorous-nihilistic.

Not at all like Stephen Dedalus, then, but his stay in a sanatorium (which is his university) involves him in an extended debate between Settembrini (modelled on the humanism and progressive liberalism of Émile Zola and his successors, including Mann's novelist brother Heinrich), and the cunning conservatism of Leo Naphtha (who is 'anti-reason', and is Jewish, Jesuit, elitist, and communist, and modelled on Georg Lukács). And, towards the end of the novel, we hear from Peeperkorn (who represents the Nietzschean Dionysian principle, and is modelled on Gerhart Hauptmann). Through them, the rather dim Castorp goes through one *Weltanschauung* after another, that is 'humanism, spiritualism, psychoanalysis, and primitive communism laced with Gnostic heresy'. In this debate on the mountain, he is supposed to rise above the usual social conditions down below and to achieve a kind of contemplative detachment, but, as we shall later see, the resolution of Castorp's dilemmas is of a rather different, non-discursive kind.

Throughout, Castorp and the reader have to battle with those hypostatized abstractions, which many see as part of German culture, and so the philosophical and cultural contrasts which Mann wishes to bring forward lack any really concrete exemplification. E. M. Forster manages such contrasts, through a similar awareness of the relationships between realism, symbolism, and religious myth, far more specifically, in the three contrasting parts of his most modernist and poetic book, *A Passage to India* of 1925, in which English imperialist worldviews and those of Muslims and Hindus are brought into a state of dramatic conflict and contrast.

The 'high culture' for such writers preserves culturally significant ideas, in forms that make them accessible on all sorts of levels, and also presents the issues that trouble the culture in a problematic and debatable form. And this is precisely what we can say for major works such as *The Waste Land*, *The Tower*, *Ulysses*, *Berlin Alexanderplatz*, *A Passage to India*, *Á la recherche du temps perdu*, *Jonny spielt auf*, *The Magic Mountain*, *The Orators*, *In Parenthesis*, *Between the Acts*, *The Man without Qualities*, *Dr Faustus*, and the *Caucasian Chalk Circle*. To this extent, modernism has a close affinity to the conflicts of the tragic tradition – but it is notable that the works just cited nearly all have a comic and ironic character, which, with its implicit appeal to ordinary human response, generally keeps the pretentiously theological at a distance, and the claims of philosophy (though not of morality) nicely relativized.

For such modernists, canonic works were their points of reference for important and essentially contestable moments in the past history of humanity, some serious and centrally based, such as Eliot's use of Chaucer and Wagner and Buddha and vegetation myth in *The Waste Land*, and others more marginal, as in Pound's early *Cantos*, with their juxtapository adaptation of the paratactic style of Browning's poetry, reliance on Fenellosa's view of Chinese, use of the economic theories of Douglas, and highly idiosyncratic reading of Renaissance and economic history, all of which have proved to be more marginal to later 20th-century concerns than those of Eliot.

Such themes are, taken together, inherently liberalizing in effect, providing means by which we can come to terms with and understand the plurality of worldviews and the contrast of values within Western civilization, and also understand how the modern age came to be. Above all, it avoided the manic certainty and selectivity of those ideologies which were to oppose modernist art in the 1930s and beyond.

The idea of myth

We can perhaps see all this a bit better in relation to a more extended example.

The psychological indictment of contemporary life in *The Waste Land* was easily appreciated by its early commentators. I. A. Richards saw the poem as an expression of 'the state of mind of a generation after the war'; and as concerned with 'sex as the problem of our generation as religion was of the previous one'. And C. Day Lewis thought that: 'It gives an authentic impression of the mentality of educated people in the psychological slump that took place immediately after the war.'

But the larger issues within the poem, particularly of religion, were not so easily seen, because here, as in *Ulysses*, they are seen in terms of myth, which was thought of by many modernists (particularly those of a psychoanalytical turn of mind) as expressing not just the 'primitive' fantasies of contemporary human beings, but also the child-like nature of the beginnings of the race; and through that arose the troubling thought that ancient myth may secretly underlie modern experience, particularly when it is sexual or regressive. That is what Eliot is relying on in *The Waste Land*, having admired Joyce for doing the same thing in *Ulysses*. Eliot indeed thought of the 'mythical method' he found there as comparable, for its potential effect on creative writing, to 'the discoveries of Einstein'. This is because 'Psychology (such as it is, and whether our reaction to it be comic or serious), ethnology, and *The Golden Bough* have concurred to make possible what was impossible even a few years ago'. (It was apparently impossible even for Yeats, who is unfairly hailed here as a mere 'adumbrator' of the method.) The mythical method was 'a step towards making the modern world possible for art' (and here is the proclaimed cognitive gain). For given the allusion from A to B, there can also go a critical juxtaposition, for example, in *The Waste Land* when the lovers on the

Thames of the present – the girl in the canoe, seduced near Richmond – seem to be much more sordid than the lovers – Queen Elizabeth and Leicester – dallying on the Thames in a royal barge of the past – or are they?

Eliot and many of his contemporaries went to the culture of ideas for a conception of myth which is inherently problematic and debatable, as we can see if we look at the divergence of views expressed in his many sources. The modernist use of myth in creative work is an amalgam of various conflicting discourses, all of which have their own interesting relations to the culture in which the artist works. For Eliot alone, we would have to look at a wide range of possible sources, such as those mentioned in the 'bogus scholarship' of the notes to *The Waste Land*. Once we embark on such a search, as so many have done in the hope of finding a master myth to unite the poem, we will find that we also have to contend with Eliot's thoughts about the relationship of myth to primitivism and religion, his reading of Frazer (particularly on 'The Dying God' in volume 4 of *The Golden Bough*), and of Jessie L. Weston (up to a point), and of Jane Harrison and other Cambridge anthropologists, his notions of ritual in relation to myth, and his general knowledge of anthropology from his university courses, and so on.

Once we have located such materials, we would then need to assess their varying 'cultural weight', as they go into and come out of the poem. Such discourses may be part of a conversation, or a phrase read in a book (such as Stephen Dedalus's definition of history as a 'nightmare from which I am trying to awake', which surely lies behind *Gerontion*), or come from the treatises, poems, and anthropological, philosophical, and depth psychological works alluded to above.

All these possible sources for Eliot's general idea of myth make us aware of issues or dilemmas troubling the culture, particularly, in this case, a late version of the 'can myth support or supplant

religion?' debate. These dilemmas have helped to ensure the canonic status of the work and its continued vitality in interpretation (which is similarly obvious for works like Mann's *Joseph and His Brethren* and, as we shall see, Picasso's *Guernica*). The question of the status of myth should matter as much to religious believers as it did to Eliot in *The Waste Land*, and for similar reasons. The point of the technique is indeed to make a cultural diagnosis in the light of history, so that *The Waste Land* (and Pound's *Draft of XVI Cantos*) is 'a vision of European decay' (as also are Lawrence's *Women in Love*, Mann's *Death in Venice* and *Magic Mountain*, Yeats's 'Nineteen Hundred and Nineteen', and many other texts in this period).

Most importantly, the modernist view of myth can put the arts into a new and potentially usurping relationship to history: for it can see (with Nietzsche) the writing of history itself as a form of myth-making, and conversely, myth as constituting the inevitable form of a nation's underlying history, as, for example, in Yeats's poetry and plays, where ancient Celtic myth conveniently manages to bypass the history of Christianity in Ireland by antedating it, and so find a 'true Ireland' outside the Catholic Church. Or it can support a conservative denial of 'progressive' change through a history, because it is 'really' subject (following Nietzsche again) to the mythic repetition of recurrent universals, as it seems to be in *Ulysses*. Myth is a perpetual, if conservative and perhaps pessimistic, challenge to Marxist or any other progressive views of the inner economic workings of history, as it is also to any notion, outside science fiction, that the progress of science and technology will radically transform the conditions of human behaviour. Indeed, a modernist would say that science fiction and utopian fantasy themselves tend to have all the repetitive structural features of ancient myth, which are to be found in all stages of scientific evolution.

Nearly every major modernist – Yeats, Eliot, Pound, and Auden, Gide, Joyce, and Mann, Stravinsky and Schoenberg, Matisse,

Picasso, and the surrealists – was at some stage preoccupied by this relationship of myth to culture, and used it as a narrative, structural, and allusive principle in their work.

Once modernist art could, in Arnoldian fashion, dispute the claims of religion and history to explain culture, we find that divergent works like Rilke's *Elegies*, Eliot's *Four Quartets*, and Mann's novel sequence *Joseph and His Brothers* are in a very uneasy relationship to orthodox religion as understood by the majority in the period. This is largely because art since the late 19th century had claimed to go deeper than all such orthodoxies, towards the far deeper and enduring ancient wisdom to be found in the history of religious myth-making. As Mme Blavatsky, who inspired Yeats, put it:

> It is perhaps desirable to state unequivocally that the teachings, however fragmentary and incomplete, contained in these volumes, belong neither to the Hindu, the Zoroastrian, the Chaldean, nor the Egyptian religion, neither to Buddhism, Islam, Judaism nor Christianity exclusively. The Secret Doctrine is the essence of all these. Sprung from it in their origins, the various religious schemes are now made to merge back into their original element, out of which every mystery and dogma has grown, developed, and become materialised.

Literature based on such premises had new responsibilities: as Symons put it in his *Symbolist Movement*: 'speaking to us ... as only religion has hitherto spoken to us, [literature] becomes itself a sort of religion, with all the duties and responsibilities of the Sacred Ritual'. Given the secularizing effect of modernity, the involvement of the modernists with myth and religion may seem surprising, but many of them, including the religious (Kandinsky, Mondrian), those who were to move back to orthodox religion (Eliot, Stravinsky, Auden, Schoenberg) and the doubtful but tempted (Gide), the happily unorthodox mythologizers (Yeats, Stevens) and the happily secular Bloomsbury agnostics, all saw the claims of art as in some way contesting or complementing those

of orthodox religion. Many others, like Yeats, Shaw, Lawrence, and Mann, were looking for religion substitutes, or following thinkers like Jung into the search for psychologically effective equivalents for it (Huxley, Yeats), or developing psychological arguments against it as a mere illusion, while at the same time having a strong sense of its neurotic inevitability, as did Freud. This search for an inspirational authority within the high culture rather than within religious institutions is a prime legacy of the modernist period.

Chapter 3
The modernist artist

The discovery that memories, thoughts, and feelings exist outside the primary consciousness is the most important step forward that has occurred in psychology since I have been a student of that science.

William James, *The Principles of Psychology* (1890)

The deepest problems of modern life flow from the attempt of the individual to maintain the independence and individuality of his existence against the sovereign powers of society, against the weight of the historical heritage and the external culture and technique of life.

Georg Simmel, *The Metropolis and Mental Life* (1903)

Let us examine for a moment an ordinary mind on an ordinary day . . . Let us record the atoms as they fall upon the mind in the order in which they fall, let us trace the pattern, however disconnected and incoherent in appearance, which each sight or incident scores on the consciousness.

Virginia Woolf, 'Modern Fiction' (1925)

The subjective point of view: stream of consciousness

The early tendency of modernist art was to present subjective experience, and to stress its importance, as never before. The major artists of the period, who had inherited from the late 19th century an emphasis on the role of imagery, symbolism, dreams, and the unconscious, tended always to favour the individual's self-realization, and what is more, through imaginative, intuitive, and, as we shall see, 'epiphanic' ways of coming at the truth, which were often in contention with more rational or public modes of argument. And this consideration applies to all the arts: it is as applicable to the introspections of Debussy's *Pelleas*, and Klytaemnestra's dream aria in Richard Strauss's *Elektra*, as it is to the poetry of Apollinaire and Eliot; to expressionist expression of feeling in the poetry of Gottfried Benn and Schoenberg's *Erwartung* and *Pierrot Lunaire*; to the fauvists following Van Gogh in their expression of mood by abandoning local colour; to the clearly subjective point of view of cubism, and Kandinsky's visionary abstractions.

The modernist use of 'stream of consciousness', with its reliance on image-association (which was often supposed to be driven by the unconscious), is basic to all the arts. It aims at a greater fidelity to private psychological processes, often with the characteristics stressed by Bergson, concerning the flexibility of our experience of subjective time (*durée*) as opposed to public time. When reported, such thoughts do not obey the usual public conventions of a written language, as it had previously been understood. Here, Joyce's Leopold Bloom thinks about a fish:

> Phosphorous it must be done with. If you leave a bit of codfish for instance. I could see the bluey silver over it. Night I went down to the pantry in the kitchen. Don't like all the smells in it waiting to rush out. What was it she wanted? The Malaga raisins. Thinking

of Spain. Before Rudy was born. The phosphorescence, that bluey greeny. Very good for the brain.

Or in the 'Sirens' episode of *Ulysses*, when Bloom is oddly troubled by the repeated jingling of the bell on a jarvey's carriage. We can work out that this is so, because it almost reminds him of the jingling which the brass rings above the marital bed made in his opening breakfast scene with Molly, and will make, when his wife Molly is in it with her lover Blazes Boylan, that afternoon. It is up to us to interpret these images, and to make them cohere with our notions of Bloom's personality and the 'what is going on?' of plot. This is a central combination of technique (association, including the use of indirect allusion, and without explicit logical connectives) and idea – broadly speaking, the idea of a daydreaming mental process, particularly as it expresses itself in pre-speech thought. New notions of the private are involved here. Bloom is trying *not* to think about Molly Bloom's infidelity, but all the same having lots of associations to it, and his stream of consciousness expresses what he wouldn't or couldn't anyway say out loud (for example, his fantasies about women in the 'Nausicaa' and 'Circe' episodes, or the thoughts of the idiot Benjy in *The Sound and the Fury*).

The progressive and liberating gain is obvious – Joyce's Bloom really does have a fascinatingly 'ordinary' mind, Stephen Dedalus an amazingly creative one; and Molly's thoughts don't just take us into an account of her love-making, but express attitudes towards Boylan which would certainly not be part of her conversation, and reveal, as much modernist writing does, aspects of female sexual response which were significantly absent from the 19th-century novel.

> Titties he calls them I had to laugh yes this one anyhow stiff the
> nipple gets for the least thing I'll get him to keep that up and Ill take
> those eggs beaten up with marsala fatten them out for him what
> are all those veins and things curious the way its made 2 the same in
> the case of twins theyre supposed to represent beauty placed up
> there like those statues in the museum one of them pretending to

hide it with her hand are they so beautiful of course compared with what a man looks like with his two bags full and his other thing hanging down out of him or sticking up at you like a hatrack no wonder they hide it with a cabbageleaf.

The idea that the artist can in this way make a cognitive gain for us all in terms of psychological realism is clearly stated by Virginia Woolf, and it marks a conceptual shift, towards an exploration of particular philosophical ideas about subjectivity, which brings about a paradigm change in the 20th-century conception of the self. In realist novels, according to her:

> Every sort of town is represented, and innumerable institutions; we see factories, prisons, workhouses, law courts, Houses of Parliament; a general clamour, the voice of aspiration, indignation, effort and industry rises from the whole; but in all this vast conglomeration of printed pages, in all this congeries of streets and horses, there is not a single man or woman whom we know.

Woolf then imagines a Mrs Brown sitting opposite her in a railway carriage, as she might be described by H. G. Wells, John Galsworthy, or Arnold Bennett. These authors seemed to her to be 'of great value and indeed of great necessity', but their books 'leave one with so strange a feeling of incompleteness and dissatisfaction. In order to complete them it seems necessary to do something – to join a society, or, more desperately, to write a cheque.' She then describes how inadequately these three novelists would treat Mrs Brown, but 'The capture of Mrs Brown' is the title of the next chapter in the history of literature; and, 'let us prophesy again, that chapter will be one of the most important, the most illustrious, the most epoch-making of them all'. This 'capture' was attempted, in a brilliantly new, wholly un-Joycean, evocation of consciousness, by Woolf herself in her novels from *Jacob's Room* onwards. The main reason for her pursuit of this technique was that it was truer to Mrs Brown, and also preserved her inner, and quite ordinary,

dignity (as the crazy thoughts of Septimus Smith do too, in *Mrs Dalloway*).

Musicians and writers and painters were united in this interest in the nature of private experience within modern conditions, and notably within the city. In such a light, we must think of *The Waste Land* as exploring the private, confessional, and neurotically confused nature of Eliot's experience of sex in London. And similarly, be aware of the nature of background but hardly concious preoccupations when we look at Bloom's, Molly's, and Stephen's different responses to Dublin in *Ulysses*, or the three brothers in Faulkner's *The Sound and the Fury*, or Mrs Dalloway walking along Picadilly and Bond Street. We have the sense, not just of occupying another person's mind, which can arouse morally and politically significant feelings of identification and sympathy, but also of appreciating the identity of an individual linguistic sensibility within a particular cultural milieu. It is not that external factors are absent, but that they are to be seen from an individual's perspective, thus abolishing, ignoring (or indeed silently presupposing), the realist knowledge of a reliable author. But what these psychological realists know about is something different:

> ... Big Ben strikes. There! Out it boomed. First a warning, musical; then the hour, irrevocable. The leaden circles dissolved in the air. Such fools we are, she thought, crossing Victoria Street. For Heaven only knows why one loves it so, how one sees it so, making it up, building it round one, tumbling it, creating it every moment afresh; but the veriest frumps, the most dejected of miseries sitting on doorsteps (drink their downfall) do the same; can't be dealt with, she felt positive, by Acts of Parliament for that very reason: they love life. In people's eyes, in the swing, tramp, and trudge; in the bellow and the uproar; the carriages, motor cars, omnibuses, vans, sandwich men shuffling and swinging; brass bands; barrel organs; in the triumph and the jingle and the strange high singing of some aeroplane overhead was what she loved; life; London; this moment of June.

A respect for the individual's *subjective point of view*, and a distrust of conformity and group consciousness (such as the political judgement of the Citizen in *Ulysses* and the professional medical assumptions of Dr Bradshaw in *Mrs Dalloway*) is a major aspect of modernism. Many major novels investigate the point of view of a particular consciousness. Joyce's Stephen, Proust's Marcel, Mann's Hans Castorp, Woolf's Lily Briscoe, Alfred Döblin's Franz Biberkopf, Robert Musil's 'Man without Qualities'. And the poets, like Wallace Stevens, William Carlos Williams, W. B. Yeats, T. S. Eliot, Rainer Maria Rilke and Gottfried Benn, and many others, also carried within themselves the new epistemology of the age, as did, in particular, heroically subjective painters, from Wassily Kandinsky to Salvador Dali and Max Ernst, and musicians like Arnold Schoenberg and Alban Berg.

The growth of the analysis of the subjective point of view is seen philosophically in Bergson and psychologically in Freud, but was most rigorously pursued in the subjective self-reliance of modernist art, which delineated this kind of psychology, and also traced the growing emancipation of the expressive or creative individual from socially accepted forms of belief (as in Joyce's portrait of himself as Stephen Dedalus), or gave the reader an intimate sense of a differing or dissentient identity; and most interestingly, so far as the politics of our reading is concerned, those of women – as the heroine of Dorothy Richardson's huge stream-of-consciousness novel sequence, Molly Bloom, Mrs Dalloway, and Lily Briscoe show.

Epiphany and vision

Most striking within this mode is something that, following Joyce, one can call a reliance upon epiphanic experience. This can be broadly defined as a revelation, achieved not through discursive thinking, but from the close subjective apprehension of something which is entirely *particular*. Of course, there are foreshadowings of this in the literary tradition, from William Wordsworth and Gerard Manley Hopkins and French symbolism, and from

George Eliot to Joseph Conrad. But Joyce baptized a psychological process that was going to be central to modernist art.

> This is the moment which I call epiphany. First we recognize that the object is *one* integral thing, then we recognize that it is an organised composite structure, a *thing* in fact: finally, when the relation of the parts is exquisite, when the parts are adjusted to the special point, we recognize that it is *that* thing which it is. Its soul, its whatness leaps to us from the vestments of its appearance. The soul of the commonest object, the structure of which is so adjusted, seems to us radiant. The object achieves its epiphany.

This argument would also provide an explanation of the intended effects of much abstract art and still life painting, and could be an early sketch for the Bloomsbury notion of 'significant form'. But it is a further consequence, an intuition into the nature of reality, which is central to literary epiphany, as it occurs in Joyce, Mann, Woolf, Jean-Paul Sartre, and others. Joyce tends to see it as a psychological process of aesthetic detachment (which descends from Walter Pater) in which the mind is 'arrested' and 'raised above desire and loathing', within 'the most satisfying relations of the sensible' (which would apply particularly well to our apprehension of an art like Mondrian's).

And yet Stephen's example in *A Portrait* is a very Kantian one, of looking at a commonplace basket: 'you pass from point to point, led by its formal lines; you apprehend it as balanced part against part within its limits; you feel the rhythm of its structure'; it is a *thing*. 'You apprehend it as complex, multiple, divisible, separable, made up of its parts, the result of its parts and their sum, harmonious. That is *consonantia*.' 'Bulls eye', says Lynch, 'wittily'.

Woolf gives this kind of apprehension a far greater, less formal significance, and sees the relationship of the thing to the rest of the world as potentially revelatory.

I was looking at the flower bed by the front door; 'That is the whole',
I said. I was looking at a plant with a spread of leaves; and it seemed
suddenly plain that the flower itself was a part of the earth; that a
ring enclosed what was the flower; and that was the real flower; part
earth; part flower. It was a thought I put away as being likely to be
very useful to me later.

Indeed, it was useful:

I feel that I have had a blow; but it is not, as I thought as a child,
simply a blow from an enemy hidden behind the cotton wool of
daily life; it is or will become a revelation of some order; it is a
token of some real thing behind appearances; and I make it real by
putting it into words.

... It is the rapture I get when in writing I seem to be discovering what
belongs to what; making a scene come right; making a character come
together. From this I reach what I might call a philosophy; at any rate it
is a constant idea of mine; that behind the cotton wool is hidden, a
pattern; that we – I mean all human beings – are connected with this;
that the whole world is a work of art; that we are parts of the work of
art. *Hamlet* or a Beethoven quartet is the truth about this vast mass that
we call the world. But there is no Shakespeare, there is no Beethoven;
certainly and emphatically there is no God; we are the words; we are
the music; we are the thing itself. And I see this when I have a shock.

This intuition of mine – it is so instinctive that it seems given to me,
not made by me – has certainly given its scale to my life ever since
I saw the flower in the bed by the front door at St Ives.

What Woolf says here reflects a very general 20th-century
scepticism about the group claims of philosophy, religion,
and ideology in general. It is the individual who organizes
experience – giving it the coherence, not of philosophy or religion,
but of a work of art or of a narrative. The 'self' is not a walking
compendium of moral principle, virtues and vices – that is, the
outside view – but something which maintains the 'story' of an

individual. It is this artistic ordering, local, but often extraordinarily strong and extended in its effects, as, for example, in Proust, upon which so many modernists rely.

It underwrites Lily Briscoe's final 'vision' in *To the Lighthouse*. She is trying to complete a picture which contains 'Mrs Ramsay sitting on the step with James'. (But Mrs Ramsay, who is central to the first part of the novel, has died some time before.) Her subsequent 'revelation' about life is wonderfully poised between the nature of the object, the historical event, and the nature of art in giving it order. This is just what painting does, perhaps, but perhaps not, because she is not just thinking about her painting here:

> Heaven be praised for it, the problem of space remained, she thought, taking up her brush again. It glared at her. The whole mass of the picture was poised on that weight. Beautiful and bright it should be on the surface, feathery and evanescent, one colour melting into another like the colours on a butterfly's wing; but beneath the fabric must be clamped together with bolts of iron.

And as she sees through the window that someone has come into the drawing room behind it, and fears that it may disturb the design of her canvas, she thinks that:

> One wanted, [she thought], dipping her brush deliberately, to be on a level with ordinary experience, to feel simply that's a chair, that's a table, and yet at the same time, It's a miracle, it's an ecstasy. The problem might be solved after all.

The central moments in Eliot's *Four Quartets* – which indeed presuppose an orthodox Anglican belief – aim at capturing just such epiphanic experiences, centred on symbols, and overtly aesthetic, not least because of the poet's extraordinary self-consciousness about the language of the poetry he is making, which is itself the theme of the final section of each 'quartet'. So that by the end of 'Burnt Norton':

> Words move, music moves
> Only in time; but that which is only living
> Can only die. Words, after speech, reach
> Into the silence. Only by the form, the pattern,
> Can words or music reach
> The stillness, as a Chinese jar still
> Moves perpetually in its stillness.

The poem, conscious of itself, gives a symbolic meaning to this stillness of the whole poem, which is full of symbolic leitmotifs, so that it connotes theological notions, here of God as an 'unmoved mover'. So this rather Keatsian reflection on the autonomy of the work of art also has its deeper metaphysical implications. And the reliance here on notions of form and pattern again strongly suggests the contemplation-inducing 'significant form' of abstract art. The poem also takes advantage of the nonverbal abstraction of music – that is, the music of its own poetic movement, as well as its use of a musical symbolism, which again has theological implications, which are nevertheless seen as rooted in a significantly individual epiphanic experience:

> Not the stillness of the violin, while the note lasts,
> Not that only, but the co-existence,
> Or say that the end precedes the beginning,
> And the end and the beginning were always there
> Before the beginning and after the end.
> And all is always now.

As Kermode has put it, what is dominant here is 'the Symbolist conception of the work of art as aesthetic monad, as the product of a mode of cognition superior to, and different from, that of the sciences'. The *Four Quartets* are in many ways the symbolist poem that Stéphane Mallarmé wanted to write.

Modernist epiphany may be a bit mystical, but it need not be at all theological, as Jean-Paul Sartre shows us in *La Nausée*, written from 1931 to 1936 and published in 1937. Like Woolf and Eliot, he sees art as a model for order through his narrator, the local historian Antoine Roquentin: 'Yes, it's what I wanted – alas! What I wanted. I am so happy when a negress sings ['*One of these days*']: what summits would I not reach if *my own life* were the subject of the melody.' Then:

> This what I have been thinking: for the most commonplace event to become an adventure, you must – and this is all that is necessary – start *recounting* it. This is what fools people: a man is always a teller of tales, he lives surrounded by his stories and the stories of others, he sees everything that happens to him through them; and he tries to live his life as if he were recounting it.
>
> But you have to choose: to live or recount.

This last sentence is the key to the existentialist liberation from a modernist aesthetic modelling of life – towards a kind of living spontaneity, which becomes existentialist responsibility. Roquentin's 'sudden revelation ... I am as happy as the hero of a novel' stems from a feeling of complete contingency, whereas Woolf's led to a metaphysically acceptable sense of connectedness (and of relationship to the object). For Roquentin:

> existence had suddenly unveiled itself. It had lost its harmless appearance as an abstract category: it was the very stuff of things, that root was steeped in existence. Or rather the root, the park gates, the sparse grass on the lawn, all that had vanished; the diversity of things, their individuality, was only an appearance, a veneer. This veneer had melted, leaving only soft, monstrous masses, in disorder – naked, with a frightening obscene nakedness. ...
>
> We were a heap of existents inconvenienced, embarrassed by our selves, we hadn't the slightest reason for being there, any of us, each

existent, embarrassed, vaguely at ease, felt superfluous in relation to the others.

The next paragraph begins: 'The word Absurdity is now born beneath my pen', and with it, post-war existentialism, with moral and political commitments which moved from a modernist to a postmodernist way of seeing the universe. For moderns, it was at best unified like a work of art; but for the atheist existentialist it is ironically contingent, making no sense except a comic one, with no particular place for human beings, who have to try vainly to come up with a narrative explanation. As they do in the writings of Albert Camus and Samuel Beckett, for whom life may or may not be any more satisfactory than Roquentin's conclusion here: 'Every existent is born without reason, prolongs itself out of weakness and dies by chance.'

All of these works have important connexions to social frameworks of belief: but the visionary high modernism which questioned those frameworks depended almost entirely on the very high value it placed on the integration of the individual, subjectivist view of life: a view which, as we shall see, will come under the severe stress and test of political demands in the 1930s, and against which existentialist individualism revolts.

Modernist heroes

In the previous section, I tracked some epiphanic experiences through three writers in English, and then turned to Sartre, as giving an existentialist turn. But a very similar line of development could have been shown for all the major European literatures, for example in Marcel's development through to the final revelations of Proust's *Á la recherche du temps perdu*, through André Gide's self-consciously reflexive account of novel-making in *The Counterfeiters*, to Sartre; or from Aschenbach's final dream vision in Mann's *Death in Venice*, through the experiences of

Franz Biberkopf in *Berlin Alexanderplatz* (which is hugely indebted to Joyce's *Ulysses*), to the possibly final, but never finally written, visions of Ulrich in Robert Musil's *The Man without Qualities*.

Such developments are central to much modernist work, and in particular to the far from ordinary kind of heroically subjective consciousness shown by many of its heroes: and so, for example, the resolution of Hans Castorp's philosophical perplexities in *The Magic Mountain* comes in the form of a dream-like experience in a snowstorm.

This final dream, deriving from Nietzsche's *Birth of Tragedy*, is a vision confined to a particular moment, what Stern calls 'privileged moments on the very margins of ordinary life'. He realizes after reflecting on the arguments he has heard (and Mann italicizes it for us) that '*For the sake of goodness and love, man shall let death have no sovereignty over his thoughts.*' But this is the conclusion of a number of reflections about his dream-like experience, in which 'we dream anonymously and communally, if each after his fashion. The great soul of which we are a part may dream through us.' There is a side to humanity which rationalism ignores, and which Castorp sees in the snow. The conclusion, that 'Man is master of the antitheses' because 'they are through him, and he is nobler than they', is very like that of Yeats in the thirteenth phase of *A Vision*. Castorp, in the end, before he is overtaken by history on the battlefields of Flanders, comes out on the side of Settembrini, the liberal humanist: life is what we interpret it as being. It has no hidden or transcendent source of meaning.

Henry James is of course the significant predecessor here, having centred his novels on the baffled but intelligent hero or heroine in *Portrait of a Lady*, *The Ambassadors*, and *The Golden Bowl*. But Stephen Dedalus, both Blooms, Musil's ironically described 'Man without Qualities', and others, and, as we shall see, surrealist

heroes, inside and outside of art, in literature and in painting, all have this kind of experience. But they tend not to be heroes of action: as Quinones remarks, there is an 'absence of will' in Marcel, Castorp, Bloom, Tiresias, Jacob, Mrs Dalloway, and the six characters in *The Waves*. They tend to be 'reflective, passive, selfless and tolerant witnesses'. As Charles Russell puts it:

> Thematically, modernist novels present characters who constantly confront a disruptive and perhaps meaningless environment, as do Hemingway's, Woolf's, Musil's, and Beckett's, with nothing to fall back on other than personal heroism, brute sensation, or endangered consciousness.

In Kafka's *The Trial*, we are claustrophobically caught within the subjective responses of the hero, K, with no relief or reassurance about the actual nature of the reality he faces, as he struggles within an apparently absurd, but actually deadly, world. His bafflement and resignation about all the supposedly 'legal' processes that surround him is horrifically fixed within his mind, which, as his top-hatted executioners come for him, he can only resolve to 'keep clear to the end'. He is knifed to death in a 'small stone quarry'.

> Was help at hand? Were there some arguments in his favor that had been overlooked? Of course there must be. Logic is doubtless unshakeable, but it cannot withstand a man who wants to go on living. Where was the Judge whom he had never seen? Where was the High Court, to which he had never penetrated?

His reactions have come for many to stand in for all the anger and bafflement provoked by the injustices of bureaucracy and government and racial persecution in the 20th century. And shame. As K dies, 'it was if he meant the shame of it to outlive him'. I agree with Quinones that:

> The creation of these complex central consciousnesses constitutes one of the major achievements of modernism, an achievement that

is epoch-making in several ways. In these characters, and their mode of perceiving, we were given the form of the intellect for roughly the next forty years of our culture – spanning more than two generations. We were given the form of twentieth century man.

So much of what Bloom sees is indeed modernity: he is, like Prufrock and Hugh Selwyn Mauberley, and even Mrs Dalloway, 'a perfect instrument for registering the variety, the flux, the interpenetration, the simultaneity and randomness of experience'.

This attention to consciousness, for modernists, is one which also allowed a far greater attention to sexual response – hence the problems of many modernists with censorship, and not least for D. H. Lawrence, who pursued what he saw as a new kind of representation of the body (for which he had to invent a new – and relatively chaste – language, until he wrote his third version of the story of *Lady Chatterley*). Lawrence sees this new subjectivism as something that gets at truths which are independent of the falsifying moral schemas to be found even in the greatest parts of the literary tradition. In a famous manifesto of intent, his letter to Edward Garnett in June 1914, he says that he is impressed by the futurist leader Marinetti, and his aim at 'an intuitive physiology of matter', because:

> that which is physic – non-human, in humanity, is more interesting to me than the old-fashioned human element – which causes one to conceive a character in a certain moral scheme and make him consistent. The certain moral scheme, in Turgenev, and in Tolstoi, and in Dostoievsky, is what I object to.

And his central concern here was women's sexual responses:

> I don't so much care about what the woman *feels* – in the ordinary usage of the word. That presumes an *ego* to feel with. I only care about what the woman is – what she is – inhumanly,

physiologically, materially – according to the use of the word:
but for me, what she is as a phenomenon (or as representing
some greater, inhuman will), instead of what she feels according
to the human conception.

And so:

> You mustn't look in my novel for the old stable *ego* of the character.
> There is another *ego*, according to whose action the individual is
> unrecognisable, and passes through, as it were, allotropic states which
> it needs a deeper sense than any we've been used to exercise, to
> discover are states of the same single radically unchanged element.

This made Lawrence's friend, the critic Middleton Murry, claim in
his review of the novel that he could not distinguish between
the characters in *Women in Love* (he was the model for one of
them). But this in a way confirmed the originality of Lawrence's
approach to persons within a body: notably in his highly
symbolized description of the conflict between his heroine
Ursula and the rigid, imperialist, militaristic Skrebensky when
they make love in *The Rainbow*.

> He strove subtly, but with all his energy, to have her. And always she
> was burning and brilliant and hard as salt, and deadly. Yet
> obstinately, all his flesh burning and corroding, as if he were invaded
> by some consuming scathing poison, still he persisted, thinking at
> last he might overcome her. Even, in his frenzy, he sought for her
> mouth with his mouth, though it was like putting his face into some
> awful death. She yielded to him, and he pressed himself upon her in
> extremity, his soul groaning over and over:
>
> 'Let me come – let me come'
>
> She took him in the kiss, hard her kiss seized upon him, hard and
> fierce and burning corrosive as the moonlight . . . and her soul
> crystallised with triumph . . .

Skrebensky's 'let me come' was censored out of the original edition of 1915, which was condemned by many indeed as 'a greater menace to our health than any of the epidemic diseases', and prosecuted for obscenity and withdrawn from circulation. Lawrence's basic problem was to show that the development of his heroines' responses to life were resolutely 'physiological', and so get below the normal levels of consciousness. This can be evoked if necessary in symbolic terms, as they are in Ursula's final epiphanic encounter with horses, at the end of the novel. And so she finds that love is not just sexual awakening [chapter xi], or the narcissism of a corrupt mechanical society [chapter xii], or idealism in personal relationships [chapter xiii], or the stagnant warmth of the family [chapter xiv], or even a 'dark sexual ecstasy' which engages only a part of the self [chapter xv]. The mode of expression here is not the realism of Bennett and others, but a visionary symbolism, as Ursula experiences an adolescent love affair, a Lesbian attachment, two years as a pupil-teacher, a broken engagement, three years as a university student, and the loss of a baby, all as part of a trajectory of self-realization – which is a great modernist value, and opposed, so far as Ursula can manage it, to subordination to any political or institutional forces.

In the sexual realm, Lawrence has to do all this without relying on the mere external physical description and clichés of pornography, a challenge he faced particularly, for example, in the 'Excurse' chapter of *Women in Love*, in which he may well be describing anal penetration between his hero, Birkin, and Ursula. The moral disadvantages of such sexual scenes, as written from a dominating male point of view, have frequently been pointed out by feminist critics. But it is the technical achievement in this novel (peculiarly like that attempted by Wyndham Lewis, in his much more violent and chauvinist work, *Tarr* [1914]) that counts for Lawrence's modernism, in promoting new and challenging attitudes to sexual relationships, through the invention of an often overwrought, poetic, imagistic, and strongly rhythmic prose, even if in an

occasionally rather ludicrous vocabulary. As Julian Moynahan has pointed out:

> It is certainly true that Lawrence did not fully succeed in the enormously difficult task of clarifying the relation of his 'inhuman selves' to social roles on the one hand and to vital forces on the other. The difficulty was partly technical; after all, Lawrence had to invent numerous new aesthetic forms in order to reveal new aspects of reality and the drama of essential being.

Just as surely as Henry James lurks behind his Lambert Strether (and Lawrence behind his hero Birkin in *The Rainbow* and *Women in Love*), we find that the ultimate heroic consciousness in this period is that of the great artist, associating as much as arguing, capable of many styles and perspectives, and nearly always possessing a saving irony. The artist is often the disguised hero of the work (like Proust as Marcel the monologuist; Joyce as the 'Arranger', whom we have to track; and the novelists in Gide's *The Counterfeiters* and Aldous Huxley's *Point Counter Point*). Many modernist works also celebrate a positively encyclopaedic and sometimes essayistic control by the writer, also to be found in *The Magic Mountain*, *Dr Faustus*, *The Glass Bead Game*, *The Man without Qualities*, and others (an attempt which sometimes signally fails, as in *Finnegans Wake* and the *Cantos*).

This encyclopaedic control is often married to a great formal virtuosity – most notoriously perhaps in Joyce's *Ulysses*, which was widely thought to have brought the novel to an end, since it had exhausted its technical possibilities. Indeed, this formalism is thought by some to be a leading modernist characteristic, which somehow marks a retreat from experience into purely aesthetic concerns. But I have tried to show above that most formal experiment had exploratory, mimetic, and cognitive purposes (even in the case of abstract art, aiming at the transformation of the viewer through the emotions aroused in contemplation). It is nevertheless the case that a great deal of modernist art follows

Henry James and others in being very self-conscious about the application of its own procedures.

This formal virtuosity is also to be found in music and painting, particularly in the many modernist painters who worked in series, using thematic repetition and variation. Thus we can 'read' the serial development of cubist still life; Kandinsky's many variations on biblical themes through a progressive abstraction; Pierre Bonnard's devoted variations on domestic scenes in which his wife Marthe is washing or bathing; and of course Paul Cézanne's many confrontations with Mont St Victoire; and Claude Monet's celebrations of his garden in Giverny, in many variations from 1892 to 1926, in this way. All these artists (let alone those who, like Dali, insisted on being seen as such) are the implicit hidden heroes of such work; very obviously, for example, in Picasso's *Vollard Suite* of etchings, forty-six of which are of 'The Sculptor's Studio', made in 1933–4, and tell a story of the creative process. Many of these show a person contemplating a completed sculpture, in a style of depiction contrasting to their own. Picasso thinks about sculpture by drawing it, and so in this sequence elaborated a pre-Christian, pagan, and Arcadian mythology of sex, which surrounds his own practice. In one of them, a classically beautiful woman looks at a surrealist sculpture, made out of balls, a cushion, table legs, and so on; and in others, an Olympian god or hero is depicted to stand in for the artist – in one etching, he is a river god reclining by the Three Graces. In this sequence, there is depiction in a large range of styles, all recreated with affection and humor, many of them erotic, depicting sexual situations in a realistic rather than abstracting style, and all redolent of that mastery of differing techniques which is so typical of the major modernists.

Perhaps the most astounding example, outside *Ulysses*, of encyclopaedic formal procedures, also deeply indebted to the past, is Alban Berg's opera *Wozzeck*. Its fifteen scenes are divided symmetrically into three acts, organized as exposition, development, catastrophe (and epilogue), thus paralleling sonata

form. The first act contains five character pieces, the second is organized like a symphony, and the third is a series of inventions on musical elements (theme, note, rhythm, chord, and key). Berg has brought classical forms, in atonal style, into the opera, as happened in the Baroque and Classical periods, but without for a moment sounding either ironic or neoclassical. Berg was as keen as Joyce was that his underlying design should be recognized, sending out a schema with each copy of the score, but he is also clear that we do not need to be able to recognize, for example, the twenty-one variations of the *passacaglia* in Act I, scene 4. As in *Ulysses*, we can be wholly absorbed in the dramatic development of plot, and the unfolding adequacy of musical expression to emotion. For at the centre of the whole structure lies the extraordinarily limited, oppressed, hardly articulate, and, in the end, mad, consciousness of the ignorant, feeling Wozzeck, with his apparent trust in God, his superstitions about being haunted by Freemasons, his hallucinations because of the diet imposed on him by his superior officer, a doctor, his babbling about sin, and ultimately his response to his wife Marie's assertion 'better a knife in me than a hand on me' when he kills her. He does this after being taunted and beaten up by her lover, the drum major, and he later drowns, trying to conceal the murder weapon. Underneath this expressionist melodrama, in music of extraordinary drama and intensity, there lies a strict and almost equally obsessional formal organization. For example, the choice of a triple fugue for Act II, scene 2 was determined by the general nature of the scene – in which each of the three characters involved pursues his own private obsession, and yet the detailed working-out of the three fugue subjects is also an exact reflection of the moment-to-moment demands of the text and stage action. Indeed, as Douglas Jarman remarks: 'It is this seemingly paradoxical fusion of technical calculation and emotional spontaneity that gives Berg's music its peculiar fascination.' The success of the opera throughout Europe after its Berlin premiere in 1925, conducted by Kleiber, is all the more remarkable in that it is a huge protest on behalf of the poor ('*arme Leute*') against a brutal and authoritarian social order.

By the time of its first performance in England, under Boult in 1934, it had been banned in Germany.

Behind all this, there is a belief in the value of the subjectively organized work, as expressing not just its specifically aesthetic conventions, but also the value of the attempt at a corresponding unification and organization of the personality. By the end of their respective narratives, Stephen Dedalus can fly by the nets of nationalism and religion, Castorp can descend from the mountain, and Eliot can come through to a positive religious affirmation at the climactic, all-theme-recapitulating end of his *Four Quartets*. This reflexivity is typical of modernism, and so its claims for the high culture were often tied to a story about persons, and particularly about the organizing powers of the mind, and it is not surprising that the invention of many modernist formalisms were thought of as being like the discoveries of order in science. Hence, too, the importance to the early 20th century of the Bildung narratives by Mann, Joyce, Pound, Gide, Hesse, Lawrence, Woolf, and Musil, amongst others.

Surrealism

These tendencies are developed to an extreme in the one radically innovatory modernist movement after 1918, which was:

SURREALISM, noun, masculine. Pure psychic automatism, by which one intends to express verbally, in writing or by any other method, the real functioning of the mind. Dictation by thought, in the absence of any control exercised by reason, and beyond any aesthetic or moral preoccupations. ENCYCL. Philos. Surrealism is based on the belief in the superior reality of certain forms of association heretofore neglected, in the omnipotence of dreams, in the undirected play of thought. It leads to the permanent destruction of all other psychic mechanisms and to its substitution for them in the solution of all the principal problems of life.

This was not the first, nor will it be the last, irrationalist challenge to a repressive culture which is thought to celebrate the wrong (rational, subordinating) powers of mind. André Breton's *Surrealist Manifesto* of 1924 makes clear such intentions: 'We are still living under the reign of logic ... But in this day and age logical methods are applicable only to solving problems of secondary interest.' And so:

> The imagination is perhaps on the point of reclaiming its rights. If the depths of our minds contain strange forces capable of augmenting those on the surface, or of waging a victorious battle against them, there is every reason to seize them – first to seize them, then, if need be, to submit them to the control of our reason.

But how can this be done? How, for example, can we arrive at a 'Pure psychic automaticism' and make discoveries in art? Part of the surrealist answer was: through the 'scientific' exploitation of physical fatigue, drugs, hunger, dreams, and mental illness (in a heroic line from Giorgio de Chirico, Jacques Vaché, and Raymond Roussel through to Jack Kerouac, William S. Burroughs, Thomas Pynchon, and many others). Many surrealists attempted to put themselves into this kind of investigatory mode (sometimes with comic rather than scientific effects, as when Robert Desnos, Max Morise, and René Crevel all competed to fall in to a 'hypnotic sleep'). Eugene Jolas's *Inquiry into the Spirit and Language of Night* (1938) gives us a good idea of the leading ideas involved:

1. What was your most recent characteristic dream (or day-dream, waking-sleeping hallucination phantasma)?
2. Have you observed any ancestral myths or symbols in your collective unconscious?

The third question is probably influenced by Joyce's *Finnegans Wake*, parts of which had been published in Jolas's journal, *Transition*:

3. Have you ever felt the need for a new language to express the
 experiences of your night mind?

T. S. Eliot replied to this, 'I am not, as a matter of fact, particularly
interested in my "night mind".'

A hilarious early example of surrealist theories in practice is given to
us in Luis Buñuel's account of his development, with Salvador Dali,
of the scenario for *Un chien Andalou* (1929) (Illustration 9): 'One
morning we told each other our dreams and I decided that they
might be the basis for the film we wanted to make.' They knew that
they 'needed to find a plot'. The film was really going to turn on its
surrealist imagery, because any kind of rational ordering was out of
the question. 'Dali said, "Last night I dreamed that my hands were
swarming with ants." I said, "And I dreamed that I cut someone's
eye in half".' That is how the film begins. There was nevertheless an
active ideological restraint for both of them: 'The way we wrote

**9. Salvador Dali/Luis Buñuel, *Un chien Andalou* (1929) Much funnier
than the famed surrealist example of an umbrella and a sewing
machine on an operating table**

was to take the first thoughts that came into our heads, rejecting all those that seemed tainted by culture or upbringing.' Surprise and release from repression were the main criteria – and they led to the wonderful scene of donkeys on a piano.

> For example: the woman grabs a tennis racquet to defend herself from the man who wants to attack her. So then he looks round for something with which to counter-attack and (here I'm talking with Dali) 'What do you see?' 'A flying toad'. 'Bad!' 'A bottle of brandy.' 'No good!' 'Well, I see two ropes.' 'Right, but what comes after the ropes?' 'He's pulling them, and he falls down, because it's something very heavy.' 'Yes, the fall's good.' 'With the ropes come two big dry pumpkins.' 'What else?' 'Two Marist brothers.' 'That's it, two Marists!' 'What else?' 'A cannon.' 'Bad! It should be a luxurious armchair.' 'No, a grand piano.' 'Very good, and on the grand piano, a donkey ... no, two rotting donkeys.' 'Wonderful!'

Buñuel was later summoned by the surrealist leader, Breton, who told him that he had seen and liked the film. But: 'It's a scandal. The bourgeois all admire you ... you've got to decide now, whose side are you on?' It sounds like a joke now, 'But it was TRAGIC. For the next few days, I seriously thought of suicide.'

We can understand some of the artistic conventions of the movement if we look at a simple surrealist object, like Meret Oppenheim's fur-lined teacup of 1936, which was called *Objet: déjeuner en fourrure* (a title given to it by Breton, to evoke Édouard Manet's painting *Le déjeuner sur l'herbe*, and Leopold von Sacher-Masoch's book *Venus in Furs*). The cup, teacup, and spoon (all from Uniprix) are covered in fur. Within a Freudian context, it was, unsurprisingly, seen as a disappointing substitute for the female genitals. Freud, in his work on fetishism, writes about 'a fixation by the sight of the pubic hair, which should have been followed by the longed-for sight of the female member'. The lack of this in women leads to penis envy, according to him. Whether or not we believe that such theories have any basis in fact,

10. Salvador Dali, *Le jeu lugubre* (1929). Painting as self-proclaimed sexual case history

we can nevertheless learn to see surrealist objects as symbolic category transgressors, arranged to appear as a 'demented form of the familiar'. And so Oppenheim's *Ma Gouvernante* [*My Nurse*] (1936) (Illustration 11) combines, literally and metaphorically, shoes, lamb chops, foot fetishism, bondage, the suggestiveness of the prone shoes with legs (heels) up, vaginal imagery, and so on. The artist later reported that it reminded her of thighs squeezed together in pleasure. Max Ernst, with whom she had an affair in 1934, had given her his wife's white shoes for the original version. But Mme Ernst destroyed it when it was exhibited in Paris in 1936.

Surrealist art produces many such puzzling metaphorical metamorphoses, of the kind, for example, to be found in many of René Magritte's paintings: in one of them (*Le Modèle rouge*), a pair of boots metamorphose into human feet, with disturbing effect, and no doubt reminding us that they are just two kinds of skin.

11. Meret Oppenheim, *Ma Gouvernante* (1936). The surrealist object as metaphor for the erotic and deviant

The most elaborately psychologized surrealist painting, and the most popular because most intelligible as a form of dream realism, is to be found in Dali, who joined the surrealists in 1919, and painted *Le jeu lugubre* [*The Lugubrious Game*] (Illustration 10) in that year, with its shit-spattered pants and large hands suggestive of masturbation. The title was suggested by the poet Paul Éluard. This is 'a veritable anthology' (as his biographer Ian Gibson puts it) of his then current sexual and para-sexual preoccupations, including 'faeces, castration, masturbation (the giant hand against swarming ants), a vulva, a figure resembling Dali's father, and innumerable other details'.

The view of sexuality in most surrealist work is neurotic, crippled, angst-ridden, and often not particularly intelligible, despite the hopes placed in an eventual psychoanalytical explanation. A large part of surrealist activity thus concentrated on a provoking anti-bourgeois sexual liberation. Changes in human consciousness should also lead to changes in society. But by the time of his *Second Manifesto* in 1929, Breton had been converted to Marxism, and had to move from saying that the Freudian dream does not recognize contradictions, to saying that surrealist work may help to reconcile contradictions, in a Hegelian Marxist sense. And so the aim (as indeed for many French intellectuals through to the postmodern period) became the making of a reconciliation between Freud and Marx (a case which was perhaps most convincingly made for the liberation movments of the 1960s by Herbert Marcuse and others). Many surrealists thus appropriated the two radically critical ideologies invented by the critical modern spirit, Marxism, and psychoanalysis – and used them to attack sexual repression and political alienation. Surrealist art therefore could function, rather well, as a highly individualistic allegory of the conflicts and tensions within the Freudian family and capitalist society.

Surrealist ideas also fitted in with the longstanding irrationalist tradition in poetry, which runs from Arthur Rimbaud through

the poets of the Dada movement, and strongly into the American tradition of painting and literature, through works like William Carlos Williams's *Kora in Hell*, Bob Dylan's *Tarantula*, and the work of John Ashbery and Hart Crane. Breton admitted that surrealism didn't really catch on in England because it was already available in Swift Walpole, Ann Radcliffe, Monk Lewis, Edward Lear, and Lewis Carroll. Its innovative properties have to do with the logic of its content rather than formal technique, though it uses all the usual modernist devices. It raises issues which extend beyond modernism: How do we communicate in a 'non-logical' way? Is a direct appeal to our emotions, or our 'primitive instincts', possible? Are we supposed to attempt an interpretation or paraphrase of the work that will add to our knowledge, or just 'accept' it as it is? (Wallace Stevens, however, thought that 'the essential fault of surrealism is that it invents without discovering'.)

All these questions make us consider the role of fantasy (as distinguished from imagination) in our lives. One of the most interesting attempts to deploy a Freudian analysis of social behaviour, and to combine that with surrealist imagery, is to be found in W. H. Auden's most modernist and experimental work, *The Orators* of 1932. He thought that all disease had psychological causes and was morally symbolic (so that if Christopher Isherwood had a sore throat, it was because he had been lying). In his 'Consider This' of 1929, the bourgeoisie are doomed for psychological as well as political reason, and the underlying thought here is the Marxist one, that capitalist society will collapse under the weight of its own internal contradictions:

> It is later than you think; nearer that day
> Far other than that distant afternoon
> Amid rustle of frocks and stamping feet
> They gave the prizes to the ruined boys.
> You cannot be away, then, no,
> Not though you pack to leave within an hour,
> Escape humming down arterial roads:

> The date was yours; the prey to fugues,
> Irregular breathing and alternate ascendancies
> After some haunted migratory years
> To disintegrate on an instant in the explosion of mania
> Or lapse forever into a classic fatigue.

By interpreting psychological disease as morally and politically symbolic, Auden's poetry linked analysis of the individual to society in general, sanctioned a revolt against the existing system, and made possible a rather condescending pseudo-clinical mode of rendering moral abstractions concrete and vivid. In *The Orators*, he develops this kind of imagery further, into a surreal account of revolution:

First Day of Mobilisation.

At the pre-arranged zero hour the widow bent into a hoop with arthritis gives the signal for attack by unbending on the steps of St. Philip's. A preliminary bombardment by obscene telephone messages for not more than two hours destroys the *morale* already weakened by predictions of defeat made by wireless-controlled crows and cardpacks. Shock troops equipped with wire-cutters, spanners and stinkbombs, penetrating the houses by infiltration, silence all alarm clocks, screw down the bathroom taps, and remove plugs and paper from the lavatories. The *Courier* Offices are the first objective. A leading article accusing prominent citizens of arson, barratry, coining, dozing in municipal offices, espionage, family skeletons, getting and bambling, heresy, issuing or causing to be issued false statements with intent to deceive, jingoism, keeping disorderly houses, loitering, mental cruelty, nepotism, onanism, piracy on the high seas, quixotry, romping at forbidden hours, sabotage, tea-drinking, unnatural offences against minors, vicious looks, will-burning, a yellow streak, is on the table of every householder in time for a late breakfast.

This parodies the plans for the mobilization of the German army in preparation for the First World War, as recounted in General

Ludendorff's *The Coming War* (1931). But Auden was soon to have doubts about the surrealist method. In the June/July 1936 issue of *New Verse*, he asks, as 'John Bull': 'What is the peculiarly revolutionary value in the automatic presentation of... repressed material?', and whether all such material has 'an equal artistic value', because 'the moment you are allowed either by yourself or by society to say exactly what you like, the lack of pressure leaves you material without form'. And if surrealists reject rationalism, how can they square their position with communism and psychoanalysis, which are, after all, rational systems? And in any case, for Auden:

> The task of psychology, or art for that matter, is not to tell people how to behave, but by drawing their attention to what the impersonal unconscious is trying to tell them, and by increasing their knowledge of good and evil, to render them better able to chose, to become increasingly morally responsible for their destiny.

Despite Breton's thought, reported above, that we may have in the end to submit 'the depths of our minds' to 'the control of our reason', very few surrealists were willing or able, as Auden was, to ally the study of fantasy to a serious moral analysis.

Chapter 4
Modernism and politics

The forms of life will become dynamically dramatic. The
average human type will rise to the heights of an Aristotle, a
Goethe, or a Marx. And above this ridge new peaks will rise.

Leon Trotsky, *Literature and Revolution* (1923)

The new age of today is at work on a new human type. Men
and women are to be more healthy, stronger: there is a new
feeling of life, a new joy in life. Never was humanity in its
external appearance and in its frame of mind nearer to the
ancient world than it is today.

Adolf Hitler, speech at the opening of the 'Great German Art'
exhibition, Munich, 1937

Individual and collective

André Breton attempted to impose a communist discipline on
members of the surrealist movement even though this meant
accepting the party line. In early 1926, he joined the Communist
Party with Louis Aragon and Paul Éluard, and by November
1926, Philippe Soupault and Antonin Artaud had been expelled for
their disobedience. In 1929, Breton and Aragon sent out a joint
letter to 76 surrealists and likely sympathizers asking if they would
engage in communal activity. On the basis of the replies, Artaud

was expelled yet again, as were Georges Bataille (who commented 'too many idealist assholes') and Robert Desnos ('all literary and artistic activity is a waste of time'); Roger Vitrac and Jaques Baron were among the 56 invitees who survived. The new political state of affairs was formalized in the *Second Manifesto of Surrealism* of that year, and it led to doctrinal divisions and denunciations by manifesto and changes in grouping, of immense complication.

The heroically subjectivist typology described in Chapter 3 therefore came under severe pressure, not just within the surrealist movement, but in general. It is at this point that we begin to see the intensely competing claims concerning heroic types in the modernist period. A collective political psychology demanding 'realism' and 'objectivity' was championed, against the idiosyncratic, aesthetically inclined individualism of the surrealists and most of the other writers and artists of the high modernist era. This conflict had horrific consequences – the Moscow trials, for example, showed how, in the light of a predestined revolutionary history, the behaviour of individual human beings could be seen as 'objectively' that of a bourgeois, anti-revolutionary group, quite independent of any conscious intentions they may have had as individuals.

Arthur Koestler's novel *Darkness at Noon* (1940) centres on the interrogations and private thoughts of a Bolshevik, Rubashov, as he awaits death in a Soviet prison. He knows that 'The Party is the embodiment of the revolutionary idea in history. History knows no scruples and no hesitation.' He later writes in his diary:

> A short time ago, our leading agriculturist, B., was shot with thirty of his collaborators because he maintained the opinion that nitrate artificial manure was superior to potash ... The cricket-moralists are agitated by.. whether B was subjectively in good faith when he recommended nitrogen.... This is, of course, complete nonsense. For the question of subjective good faith is of no interest. He who is

in the wrong must pay; he who is in the right will be absolved. That is the law of historical credit: it was our law.

By this, the expulsion of French surrealists looks relatively trivial. But there was a general issue here concerning the relationship of modernist artists to the culture in general, and it is an important one.

I have argued throughout that experimental art tends to promote the ultimately realist aim of cognitive gain, but for a Marxist critic like Georg Lukács, and indeed an anti-Bergsonian like Wyndham Lewis in his *Time and Western Man* (1927), this was looking in the wrong place. Lukács argued in the late 1930s, with Kafka in mind, that modernists reduce social reality to nightmare, as angst-ridden and absurd, thus depriving us of any sense of perspective. He claims that literature must critically utilize the bourgeois heritage and so must have a clear social-human concept of the 'normal', and this, according to him, is what modernism denounces. For him, it fails to create believable and lasting 'types', and glorifies anti-humanism and the abnormal. He defends the 19th-century realism that the modernists had subverted – hence his preference for writers like Maxim Gorky, Thomas and Heinrich Mann, and Romain Rolland, because the test of an artistic mode is political – what Lukács the Marxist sees as its 'progressive' tendencies: 'which are the progressive trends in the literature of today? It is the fate of realism that hangs in the balance.'

> By way of illustration, just compare the 'bourgeois refinement' of Thomas Mann with the Surrealism of Joyce. In the minds of the heroes of both writers we find a vivid evocation of the disintegration, the discontinuities, she ruptures and the 'crevices' – which Bloch very rightly thinks typical of the state of mind of many people living in the age of imperialism.

Lukács here anticipates the deconstructive analysis of consciousness offered by a later generation of 'Western Marxists', but it is not just the failure here to see the fact that, for example,

the only really surrealist episode in *Ulysses* ('Circe') is comic, and very critical of the main protagonists, in a cod-Freudian manner, that turns out to matter. It is the implicit dismissal of independent critical discourse, like that of this book, in favour of a collective judgement (usually in fact articulated by the Party) for the 'broad masses . . . can learn nothing from avant-garde literature, for its view of reality is so subjective, confused and disfigured'. For this 'learning', the approved traditional technique, of realism, is required, along with the 'right' connexion to the community:

> For a writer to possess a living relationship to the cultural heritage means being a son of the people, borne along by the current of the people's development. In this sense Maxim Gorky is a son of the Russian people, Romain Rolland a son of the French and Thomas Mann a son of the German people.

At this point, Marxist and Nazi totalitarianisms, with their contempt for the 'abnormal', meet.

Eric Kaufmann has defined the rise of modernism as a 'great secular movement of cultural individualism which swept high art and culture after 1880 and percolated down the social scale to liberalize attitudes in the 1960s'. As we have seen, this is generally the case; even though there were also, within the modernist experimental avant-garde, artists who were inclined in the opposite collectivist direction (as in the early unanimist movement, and in some proto-fascist aspects of futurism). But as we move into the political tensions of the 1930s, there is a growing dilemma for all artists between introspection, individual self-assertion and expression, and the claims of the collective. It is particularly interesting to see the ways in which some of them tried to reconcile an experimental and individualist tradition with their support for collective political action. Day Lewis, for example, thought that poets were 'acutely conscious of the present isolation of the individual and the necessity for a social organism which may restore communion', and George Orwell, looking back, thought that some of the solutions to this were no good:

Suddenly we have got out of the twilight of the gods into a sort of Boy Scout atmosphere of bare knees and community singing. The typical literary man ceases to be a cultured expatriate with a Leaning towards the Church, and becomes an eager-minded schoolboy with a leaning towards Communism.

Power worship

The search for group allegiance was, for many modernists in the period, a false one – it did not arise from a desire to identify with any particular community, but for an identification with a heroic leader who could solve its problems. Cecil Day Lewis saw this too:

> Here again the influence of D. H. Lawrence assists to confuse the issue. We find it, for instance, in Auden's preoccupation with the search for 'the truly strong man', [in *The Orators*] Lawrence's evangel of spiritual submission to the great individual: 'All men say they want a leader. Then let them in their souls submit to some greater soul than theirs.' And though this does not necessarily contradict communist theory, it is likely in practice to give a fascist rather than a communist tone to poetry.

The cult of the 'truly strong' individual, as the enforcer of a collective responsibility, corresponds to the power-worshipping tendency of fascism, in many ways embraced by D. H. Lawrence in his novel *The Plumed Serpent* (1927), and satirized by his friend Aldous Huxley in his *Point Counter Point* (1929).

The search for a powerful leader did not much appeal to Bertolt Brecht, who in America recapitulated *The Threepenny Opera* by writing, in 1941, a play about Hitler as a Chicago gangster. He is not the only political writer to have confronted the tension between the individual and the community, and come through a period in which he himself advocated a submission to political authority, to a later presentation of politics which was generally experimental and

modernist (and we have seen the beginnings of this in discussing *The Threepenny Opera* of 1929 in Chapter 1). In his plays written in the crisis years of the Weimar Republic, 1929 to 1932, he developed a form of theatre (*Lehrstucke*, or 'learning plays') in which working-class people were encouraged to explore vital political issues by alternating in their own performance different social roles and tactical positions. These were designed to be performed only by and for proletarian audiences, and to estrange them from the influence of 'bourgeois' moralistic and idealistic thought.

The text of *Der Jasager* [*He Who Said Yes*] was adapted as a 'school opera' by Elisabeth Hauptmann and Brecht with Weill, from a Japanese play (*Taniko*, as translated by Arthur Waley). Four young people are on a hazardous mountain journey when the youngest falls sick. Should they turn back? The boy agrees that the mission must go on – and the other three close their eyes (so that 'none is guiltier than another') and throw him off the mountain to his death. Ross comments, 'the politics may be antithetical to Hitler's, but there is the same mythologizing of the community, the same disregard for the sanctity of life', particularly in that the moral of the work is: 'Above all it is important to learn acquiescence.' It was performed hundreds of times in schools in Berlin and elsewhere.

Die Maßnahme [*The Decision*], also of 1930, which Brecht wrote to music by Eisler, is another exemplary parabolic play, directly about the conflict between allegiance to political principle and the moral right (to free expression). It is also a crucial text for the distinction between a culture which defends the individual, and the collective identity conferred by membership of a political party. The issues are presented with a stark clarity that goes beyond the obscurantist psychological and surrealist appeal to inner transformation (which Brecht had no time for) in earlier expressionist drama, despite his own play about an expressionist poet, *Baal*. In *Die Maßnahme*, young covert communist operatives in China have a Young Comrade who compromises their mission by his pity for the oppressed. He is told he must die, and acquiesces

in this and even plans it. 'You must cast me into the lime-pit... In
the interests of Communism in agreement with the progress of
the proletarian masses of all lands.' Hans Eisler wrote Bachian
chorales to reinforce the play's horrific conclusion that
'individuals count only as part of the whole'.

Hitler in Munich: the Nazis and art

The antagonistic relationship between the claims of practical
politics and the fortunes of modernist art can be immediately seen
in Europe in the attack on this type of art as 'degenerate' by the
Nazis. Although the specifics of this attack mostly affected
Germany in the period before the war, it was typical of the way in
which totalitarian politics would aim very successfully at
moving art away from subjectivity and experiment towards the
expression of collective ideas. (In the Soviet case, to a demand for
'socialist realism', away from 'bourgeois individualism' and
'formalism'.)

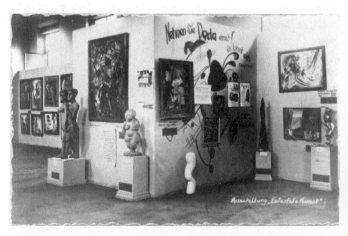

12. The background 'degenerate' abstraction here is Kandinsky's
Black Spot, reproduced in Illustration 4, and a painting by him is at the
top right

An official exhibition of '*Entartete: Kunst*' ('Degenerate Art')
opened in Munich on 19 July 1937, and then toured Germany
(part of the exhibition is shown in Illustration 12). As Peter
Adam points out:

> In its arrangement the directors, strangely enough, borrowed from
> the much despised Dadaists. The way of hanging the pictures, the
> aggressive slogans resembling graffiti on the walls, the whole idea of
> wanting to shock had all been done years before by the Dadaists.

Many of the 'degenerate' works appropriated were sold by the
Nazis at auction, but of the remaining works seized, 1,004
paintings and 3,825 watercolours, drawings, and graphic works
were later burned, on 20 March 1939, in the courtyard of the
fire station in Berlin.

Hitler's speech opening the exhibition is well worth close attention.
He presents very clearly those aspects of the modernism he wishes
to eliminate. First, it appeals to the wrong kind of (cosmopolitan)
group. The Europeanism I have emphasized led to 'an
international communal experience, thus killing altogether any
understanding of its integral relationship with an ethnic group'.
Secondly, its experimentalism is merely 'restless': 'One day
Impressionism, then Futurism, Cubism, maybe even Dadaism, etc.'
And it is the critical response to this (that is, the diffusion of its
ideas) that Hitler is also after, because 'the most insane and inane
monstrosities' have inspired 'thousands of catchwords to label
them'. It is the government which should stabilize this situation by
defining the nature of the real, that is, by demanding a
nationalistically and racially defined 'realism' in 'a German Art',
which 'will be of eternal value, as are all truly creative values of a
people'. The claims of modernist subjectivity, and its 'catchwords'
like 'inner experience', 'strong state of mind', 'forceful will',
'emotions pregnant with the future', 'heroic attitude', 'meaningful
empathy', 'experienced order of the times', 'original primitivism',
and so on, will all have to go: 'these dumb, mendacious excuses,

this claptrap or jabbering will no longer be accepted'. Nor will artists like Braque, Matisse, Kandinsky, Kirchner, Macke. Indeed, all the great German expressionists are to be decreed as degeneratively mad, because by distorting the human form, they 'see the present population of our nation as really rotten cretins'. And what is more, they 'see meadows blue, skies green, clouds sulphur yellow, and so on, or as they say, experience them as such'. This is a long way from Roger Fry. The euphemistic verbs Hitler uses to threaten the enforcement of his message are appallingly sinister: 'In the name of the German people, I want to forbid these pitiful misfortunates who quite obviously suffer from an eye disease.' And so, 'the Ministry of Interior of the Reich' will have to 'take up the question of whether further inheritance [*Verderbung*] of such gruesome malfunctioning of the eyes cannot at least be checked [*unterbinden*]', as part of 'an unrelenting war of purification [*einen unerbittlichen Säuberungskrieg*] against the last elements of putrefaction in our culture'. He promises that 'From now on . . . All those cliques of babblers, dilettantes and crooks, which lend support to one another and are therefore able to survive, will be eliminated and abolished [*ausgehoben und beseitigt*].'

Eight exhibitions of a countervailing 'Great German Art' were also held, from 1937 to 1944. In such work:

> the subject . . . has to be popular and comprehensible. It has to be heroic in line with the ideals of National Socialism. It has to declare its faith in the Aryan ideal of the Nordic and racially pure human being.

This involved a revival of classicism of the most kitschy kind. A Cologne critic described the basic thematic structure of the show: 'The worker, the farmer, the soldier are the themes. . . . Heroic subjects dominate over sentimental ones. The experience of the Great War, the German land-scape, the German man at work, peasant life'.

The Nazis' role here is exemplary, but they were not alone in violating the boundary between the political and the private, in an explicitly anti-individualist and anti-liberal posture. The critical, reflective approach demanded by Brecht (however much it may have been underpinned by an appeal to Marxist and party discipline) still grows out of the modernist willingness to distort, fabularize, and mythicize ordinary reality (as his later works show), so that we can decide, given a certain tolerance of ambiguity and conflict, through the interpretation of its metaphors, the likeness of the work to reality. And much the same goes for most of the work discussed earlier. This is very far from the 'real-life' demands upon art made by fascist parties in the 1930s, which were designed to short-circuit this reflective process by a claim (through the use of the most boring, stereotyped, and obvious kinds of photographic technique, which are, in fact, illusory in all sorts of ways) that art can mirror reality, if you have the 'right' beliefs. Hence the photographic classicism and dreadful posturing in works like Jürgen Wegner's *German Youth*, with the 'three graces' of German motherhood with small children on the left, some boyscoutish teenagers singing with drum and trumpet under a Nazi banner in the middle, and three improbably naked Spartan youths, two with spears and one with a model aeroplane, on the right; Richard Spitz's *Nazi Vision of Greatness*, in which a field full of soldiers gaze towards the sun while above them in the sky an angelic ghostly host of dead soldiers float their way towards a castle in the sky, very like that of the Wizard of Oz, with a huge shining swastika rising behind it; or Herman Otto Hoyer's picture of an orating Hitler on a dais in a dark room: the faces of his small band of listeners are illuminated, and the title is *In the Beginning Was the Word*.

The techniques of fascist and Soviet realism exploit what seems a reliable technique, to promote a ludicrously idealized, often pseudo-religious, fantasy of Hollywood proportions, with all its reassuring appeal to a popular, mass-art notion of collectivity.

It is indeed precisely the appeal to individual judgement that this kind of cultural management always attacks:

> The National Socialist revolution is a revolution of thought! Its greatness lies in the fact that it has dethroned individual thought, which governed us for centuries, and has replaced it by communal thought.

Such 'communal thought' had no place within it for critical debate, as Goebbels proclaimed in 1937: 'The abolition of art criticism . . . was directly related to the goal-directed purging and coordinating of our cultural life.' For the Nazis, modernism could be set aside as an ugly form of individualism, in favour of their version of modernity. It had become the task of the artist in Germany to reflect, faithfully, the 'new reality' as the politicians saw it, in forms as vulgar and sentimental and fantasised as the attitudes of the politicians themselves. Hence Paul Fechter's attack on Thomas Mann as:

> Remote from life and entangled in his own world of unreality, he was out of touch with the new reality in Germany, and rejecting his birthright, he left the country . . . Since he went abroad, his speeches and essays have had nothing in common with the real Germany and its spiritual life.

Progress and 'critique'

The greater part of modernist art, as I have shown, was liberating and individualist in tendency. Many later commentators on modernism have tried to point to the way in which a central tradition of modernist art was, for them, progressively part of a broadly leftist critique of society. Perhaps there are *two* traditions within modernism. One of these centres on an avant-garde, where 'progressive' is understood to have Hegelian Marxist overtones, of

an awareness of historical progress towards social emancipation (whose 'true nature' can be revealed to the initiated in philosophy or theory or the relevant technical language). Artists in this utopian tradition tend to be like those philosophers who wanted to clean up ordinary language, making it more logical, more 'scientific' (like De Stijl, the Bauhaus, and Schoenberg in some moods). Other artists see the different languages of art as inherently social, and even as a game. From within the artistic community and looking beyond it, they are aware of competition – and even to some extent of the competing discourses of power related to particular institutions. (This applies particularly to those interested in women's emancipation.) Innovation and progress for this second group will have a great deal to do with the more or less untidy historical development of institutions, of publishing, including avant-garde magazines, of critical exposure of other kinds, including cooperation with avant-gardist groups, of journalistic perceptions, and all their rivalries and cooperations. However committed they may be to particular avant-gardist groupings, their background assumption will centre on an institutional pluralism, which allows them to thrive in a debating space for opinions which have the best chance of arriving at the truth. For the extreme left and right, on the other hand, the slogan is 'stay critical', in the sense of keeping the faith, until you dominate; do not sink into a non-critical collusion with new social norms, or become too tolerant of matters like the autonomy of the work, or indeed of persons. But for the liberal centre, it is the critical debate aroused by new and challenging ideas and works of art which is centrally important.

This means that around the political centre there were anarchic, radical, and tradition-respecting groups who constructed a liberal modernism. The Dada movement, for example, which in its earlier manifestations rejected any form of organized ideology, questioned the very institutions under which they themselves operated. This made Dada, for many, the model of a radical avant-garde, leading a 'revolt against art' which attacked 'the uncritical assumption that

art embodies and legitimizes a culture's vision'. The liberal-bourgeois tradition, on the other hand, tended to identify the best in culture with the best of its art, which would endure and continue to be relevant, including the art of the past (an approach of the traditionalist and allusive modernists described earlier).

It is the nature of the avant-garde that is at issue here, if we are to attempt to understand modernist movements in general, rather than to discern and defend, selectively, leftist, liberal, or rightist tendencies within it. I agree with Diana Crane, that nearly all avant-garde art, whether it tends to left or right, is an art which is advanced in ideas and innovative or experimental in technique, and made by artists who 'have a strong commitment to iconoclastic aesthetic values and who reject both popular culture and middle class life style'. The avant-garde is thus integral to the larger functioning of the high culture, and it is centred around the solution of technical and aesthetic problems (by contrast with popular culture, which is more formulaic in its approach). These solutions, as I have tried to suggest, can make a valuable cognitive gain for the artist and the audience. A movement is therefore *aesthetically* avant-garde for Crane if it redefines aesthetic conventions, utilizes new artistic tools and techniques, and redefines the nature of the art object. And *politically* it is avant-garde (that is, in its approach to social content) if it incorporates critical social and political values which are different from those of the majority culture, redefines the relationship between high and popular culture, and adopts a critical attitude towards artistic institutions (as, for example, in Dada on the left and Eliot's *Criterion* on the right). Modernists of the left and of the right can meet these criteria. (For the right, typically enough, when capitalist technological development can be allied to a modernizing process, hence the rise of Bauhaus architecture.)

Many leftist commentators on modernism have assumed, not surprisingly, that their orientation is 'progressive' (as part of the leftist notion of historical development), and that the right's

reorientations are at best nostalgic. But one can ask whether avant-gardes, left or right, are progressive in a distinctively modernist way, or are simply the historical continuations of well-established (indeed 19th-century) political conflicts by contemporary artistic means. Is there anything inherently modernist that can be revealed by such a political analysis?

The movement model for modernism, or any artistic period, puts a huge emphasis on innovation and technical change, but the question still arises of whether they are morally or politically progressive in effect. Do they lead the period as a whole in a particular direction? This is nearly always wishful thinking. There have been many divergent avant-gardist movements, which were very successful and long-lived. But any 'linear model' for modernism as a whole will be essentially monist and ideologically driven (as, for example, Adorno's attack on Stravinsky, reported in Chapter 2, suggests). Indeed, the idea of elitist or movement-driven progress may have misled many at the time, because we can now look at the period as a whole – and see that, in fact, an eclectic pluralism and dialogue was dominant.

In music, for example, we have Strauss and Mahler, so to speak, on the romantic and self-expressive side; Stravinsky on the 'objective', and becoming neoclassical, side; and Schoenberg moving from one to the other. All three possibilities remained available, along with the far more eclectic methods of innovatory modernists like Charles Ives, Edgard Varèse, and John Cage. It is therefore always nonsensically unempirical to rely upon a hidden dialectic, in which the Schoenberg school; or the occultist revelations of De Stijl; or Yeatsian theosophy and myth; or even the development of formal qualities, like the 'flatness' which Clement Greenberg saw as the defining generic characteristic of all truly modern painting; or a 'scientific' drive towards the marriage of art and technology, as advocated by the Bauhaus, is seen as alone bearing the 'burden of progressive history' in the arts.

Imagine trying to decide, now, which of Joyce, Woolf, or Lawrence, or Picasso, or Kandinsky, or Ernst, or Mondrian, was the more 'progressive', and why – let alone asking the same question of Wells, Shaw, Brecht, and others, who really *were* committed to leftist political intervention, for in their cases the question should be easier to answer. What tends to happen is that we think of a generally acceptable line of progress, like that of feminist emancipation, and then the measure is much clearer. It puts Ibsen well ahead of Shaw; and Joyce, despite his Ibsenic beliefs, in an ambivalent position; and Eliot, Lewis, and Pound, and most of the futurists, nowhere; while Virginia Woolf, as a brilliantly subversive and culturally aware feminist, most particularly in *Between the Acts* (1941), is more or less on the 'right' lines.

This moral and political ranking, valuable though it can be in its own right, has little purchase on our understanding of the developing history of modernist art movements. A real engagement with feminist emancipation, as shown in the vast literature on it, would have to look very closely at all sorts of institutional and social groupings, at women writers and their inter-relationships, and so on.

From our perspective, we can see that divergent patterns have led to different kinds of long-term, broad cultural significance, which gives the works of major modernist artists their canonical status. And the important changes here do not just lie within the 'high' culture. As Derek Scott reminds us, 'Measured in terms of social significance, the twelve-bar blues has been of more importance to 20th-century music than the twelve note row.' The latter may be seen as more 'progressive', but only within the formal conventions of music as a whole. The social and aesthetic measures are always in interaction, and in periods of great artistic activity can be highly unpredictable.

A crippling aestheticist concentration on advances in technique (and its too-frequent corollary, the pursuit of the maximally systematic, unified work, as in the 1960s) tends to lead us to believe

that an artistic group can be alone on the true or 'necessary' line of progress. There is, for example, an obvious technically progressive connexion between the operas *Tristan* and *Elektra* and *Erwartung*, in their development of chromaticism, but what really motivates their similarities as works of art is surely derived from more generally diffused ideas about the newly uninhibited or irrational representation of women and their sexuality. As I have argued, it is the ideas behind technical change, and their more or less desirable psychological effects upon audiences, which ultimately count for notions of progress, and these ideas are to be found within and outside the arts, and they are not all obviously political.

So that 'after cubism', the human portrait figure is no longer so sacrosanct – it can be turned into a craggy landscape – and after Dada and *Erwartung*, an irrational association of ideas establishes itself as a means of understanding human nature, in works from Berg's *Wozzeck* to Maxwell Davies's *Songs for a Mad King*. As many commentators have pointed out, there are a number of different strands or genealogies to be looked at here. The major technical changes in music, for example in 1912, which saw the liberation from thematicism in Debussy's *Jeux*, the emancipation of dissonance in Schoenberg's *Pierrot Lunaire*, and the revolutionary metrics and rhythms of Stravinsky's *Rite*, could and did lead off in all sorts of directions, not all of them atonal, and none of them belonging to any particular avant-garde grouping. All three innovations were liberating, all three posed new problems for composers of all sorts of persuasions, and could be used within all sorts of representational frameworks of ideas, making possible, for example, the mystical symbolist meanderings of Karol Szymanowski's *King Roger*, and the urban savagery of Béla Bartók's *Miraculous Mandarin*, and even the ensemble comedy of William Walton's *Façade*.

It is perhaps best to see modernist techniques as capable of facing in all sorts of directions, despite the progressive claims

which have been made for favoured manifestations of them – for example, the development of political collage in the Weimar period, or Brechtian alienation effects. For enduring modernist art has indeed nearly always aimed at various political or social (or religious) effects on the mind of the reader, hearer, or spectator. Hence the feminism of Dorothy Richardson and Virginia Woolf; the nationalism of Yeats and Joyce; the social analysis of Auden and Co., and of Georg Grosz, John Heartfield (Helmut Herzfelde), and Otto Dix; the defence of Christianity by Auden, Eliot, and Stravinsky; the relationship between architecture and society proposed by Gropius and Le Corbusier; the satirical and irrationalist critique of Ernst and Aragon; the sexual emancipation aimed at by Gide, Joyce, Lawrence, and Breton; let alone the popular social critique in films like *Modern Times, Metropolis, The Battleship Potemkin*, and so on. Most of this art is, given the general assumptions of societies in early 20th-century Europe, broadly liberal or leftist in intention, in so far as it contrasts prevailing conservative political ideologies with a non-coercive but critical model of culture.

All modernist works are involved in some way with political programmes, in so far as they interacted with current political conflicts in communities. This is particularly obvious, for example, in the case of Georg Grosz and his photo-collage-making colleagues, the Herzfelde brothers (see Illustration 13). Grosz's early work as a Dadaist has a good deal of futurist and cubist geometrical articulation, but in his later career, he refines this to a much more representational, cartooning mode, believing that he was reacting 'to the cloud wandering tendencies of the so-called sacred art which found meaning in cubes and gothic', that is, expressionism. This reminds us that in all periods there is a tradition of realist art, which is strongly motivated by moral observation: and in Grosz's case, this comes out in many paintings and his portfolios of drawings – notably his *Gesicht der Herrschende Klasse* (1921) and *Ecce Homo* (1923) – maybe the most distinguished of his books. He is not just concerned with the

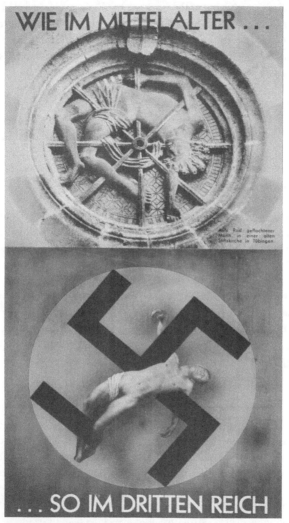

13. John Heartfield, *Wie im Mittelalter...so im Dritten Reich* (As in the Middle Ages...so in the Third Reich) (1934). The comparison of cultures by allusive photomontage; and the Nazi betrayal of the modern

betrayal or suffering of the workers, but looks at the private life of the ruling classes, seen as lechers, sex-murderers, and whores. It is a Circean, ugly, and bestial view of politics and sexuality. It symbolizes the dehumanization that arises within a capitalist society, when powerful men treat others as mere objects.

> I intend creating an absolutely realistic view of the world Man is no longer an individual, represented with acute psychological insight, but is a collectivist, almost mechanical concept. Suppress colour. The line is drawn around an impersonal photographic construction to give volume. Again, stability, reconstruction, function, e.g. sport, engineer, machine. No more dynamic futurist romanticism.

Grosz clearly made important contributions to cultural diagnosis of a political kind. His painting *Pillars of Society* (1926) has a prophetic attitude to the Nazis, as imaging right-wing violence and militarism. As Carl Einstein put it, as early as 1923:

> There is a tremendous tension between the poles of contemporary art. Constructivists and non-objective painters establish a dictatorship of form; others like Grosz, Dix and Schlichter smash reality by poignant objectivity, unmask the period and compel it to self-irony. Their painting is a cool death sentence, their observation an aggressive weapon.

Grosz depends upon the caricaturist's compromise with realism, however stylish (so does Picasso). But what happens to the political import of a fully modernist work, which exploits an advanced post-cubist technique, and relies upon many layers of historical, mythical, and artistic allusion? Many modernist masterpieces combined formal experiment and philosophical or political significance: Eliot's *Four Quartets*, for example, is a beautifully autonomous verbal structure, and also a deep analysis of Anglican theology. Of course, formalism and aesthetic autonomy (which can seem merely to be directed to private pleasures) and political commitments can be put

into opposition to one another, but in many modernist cases they cooperated (notably in *Wozzeck*).

Guernica (1937)

I began this essay with some examples and would like to conclude with one which has as great a political significance as any other. Picasso's *Guernica* (Illustration 14) combines a political mimesis, showing the horrifying effects of one of the first air-raids directed against a civilian population, and the moral outrage that follows from that, with a profound use of allusive, mythical, and formally distorting modernist techniques. Its political impact, as a study of war and terrorism, has been a lasting one, from its showings around 1937 to its present use, in a tapestry version, in a lobby of the United Nations (which was covered up when Colin Powell made an announcement in front of it about the invasion of Iraq). Its effect complements, extends, and gives a human depth to the realism which establishes historical facts. This contrast was manifest at its first showing in the Spanish Pavilion of the Paris World Fair, where 'every visitor was confronted by Gonzalez's socialist realist Montserrat at the entrance, the iron figure of a

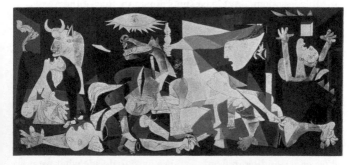

14. Pablo Picasso, *Guernica* (1937). The indiscriminate bombing of civilians – enigmatic, monumental, a masterpiece of complex allusion, and a horrible prophecy

peasant woman, standing firm against all comers with her scythe and shield', and the photographs of Guernica in flames on a floor above, alongside a wall-panel bearing Paul Éluard's poem 'La Victoire de Guernica'. This photography and socialist-realist art worked with, not against, the huge modernist mural; only together could they demand a reflective response.

When we look at modernist aspects of the painting, we can see a resurgent neoclassicism – the 'combination of stasis and turmoil' in a frieze-like work, and the 'precise sculptural manner of the great Davidian battle scenes' in a 'stately display of conflict which has a strong undertow of David's tradition'. But Tim Hilton, whom I follow, also sees *Guernica* as 'a vague painting' with a vague iconography – nobody really knows what the bull stands for, for example, and these uncertainties affect any assessment of the political effects of the work.

In October 1937, Anthony Blunt, who was then a Stalinist supporter of socialist realism, used the communitarian argument: he thought that Picasso's private imagery was really only for 'a limited coterie of aesthetes'. It poses a question: how effectively can modernist art like this be an art of opposition in the political arena? Obviously, *Guernica*'s oppositional effect at the time was probably less than, or at least subordinate to, that of the photographs which, along with the witness-testimony of newspaper reporters, established the historical, physical facts of atrocity. But as a work of art, its 'effects' are also intended to go far beyond the period of effective political intervention, and so the question arises for Blunt and his kind: do they want that kind of enduringly relevant art at all?

The answer is that *Guernica* isn't and shouldn't be just part of that local debate. It doesn't explicitly take sides in the UN either, whoever is standing in front of it. We have to decide what we now think of its moral outrage at the military or terrorist destruction of a civilian population (and, indeed, whether it applies to Iraq).

There are plenty of more recent photographs and reports to help us in newspapers and on television. Or it may 'just' be a pacifist picture, even if protesting and resigned to the inevitable continuation of this kind of injustice and the militarizing myths that support it, which, as many modernists (notably Nietzsche and Yeats) believed inevitably come round and round again.

But how does this use of myth work? Max Raphael, writing when *Guernica* was very well known, thought that the mythical symbolism was too ambivalent – the bull, for example, may be seen both as male life-force, symbol of rebirth, or even as a symbol of the impassive sadism of fascism, and the horse can be defeated fascism, or the people in sacrificial defeat. Raphael echoes Blunt in thinking that the allegory of the work is not 'self-evident', and is 'stultifying' rather than stimulating to 'creative action'. The picture is too personal, full of 'inner obsessions' (as if it were by Dali!). And so 'fails to respect real action in the real world'. 'Real' action here looks very like party action, and there is not much reason to think that it has a greater claim to be 'real' than any other kind. Christopher Green comes up with a different set of modernist considerations, reminding us that psychoanalysis claimed a universality for myth; so that the apparent banality of the symbolism here attains a complex universality by allusion, and hence a very far from private or obsessional effect. The grieving women recall a Christian crucifixion; the bull, the Minotaur; and the horse has a connexion to Spanish myths of sacrifice in the bull-ring. The range of this is indeed considerable. So we come back to the considerations raised by my opening quotation from *Ulysses*, also a mythical, neoclassical, and universalizing work, and as indubitably experimental as *Guernica*.

Picasso's picture is an excellent example of the boundary conflict of modernist with realist art and with the political demands that can be imposed on experimental work. Much obviously depends – indeed, far too much always depends – on the politics of the moment. The 'clear' political interpretation of the photographs (let

alone reporting in the press) helped to make *Guernica* urgent. But in the longer perspective, one may be more deeply and continuously grateful to the arts, and particularly those of modernism, for their neoclassical and universalizing generic models, and their continuingly humanist moral and political demands, and their willingness to bring cultures together, by seeing differing theological and political frameworks through their myths and symbols. In doing so, they can reveal something profound, and also conflicted and challenging, about human behaviour. This is what the *Guernica* picture has depended upon for its longer life as a masterpiece. It is the amazingly strong afterlife of the great modernist works, and their continuing relevance to quite different political contexts (and to a world in which Raphael's Marxism is of far less account), which should count for us.

But one might well ask which, of politics and culture, is really the container, and which the contained? I believe that a nation's culture, let alone the collective European culture which inspired most modernists (including its favoured historical narratives), should always be thought of as the container of its politics (which we must always hope can be defeated, in its worst manifestations), rather than vice versa. It is the broad and inclusive cultural sympathies of modernism which make it so essential to the culture and conflicts of the present day, which face the challenges of this century, but cannot afford to forget the historical lessons, or the artistic wisdom, of the previous one.

References

Chapter 1: The modernist work

p. 3 'jesuit': James Joyce, *Ulysses*, ed. Walter Gabler et al. (London: The Bodley Head, 1986), 1–8, 3.

p. 4 'Egypt': Hugh Kenner, *Ulysses* (London: George Allen and Unwin, 1982), 34, 35.

'cubes': Louis Vauxcelles, in *Gil Blas*, 14 November 1908, in Edward F. Fry, *Cubism* (London: Thames and Hudson, 1966), 50.

'picture': John Golding, *Cubism: A History and an Analysis 1907–1914* (London: Faber and Faber, 1959), 10.

p. 7 'life': Kirk Varnedoe and Adam Gopnik (eds.), *High and Low: Modern Culture and Popular Art*, exh. cat. (New York: Museum of Modern Art, 1991), 292.

p. 9 'text': Stephen Hinton (ed.), *Kurt Weill: The Threepenny Opera* (Cambridge: Cambridge University Press, 1990), 5f, 24, 27, 188. The alternative version of the execution scene can be found in *The Threepenny Opera*, tr. Ralph Mannheim and John Willet (London: Methuen, 1979), 121f.

p. 10 'blue': F. S. Flint, in *The Times*, cit. Alan Young, *Dada and After: Extremist Modernism and English Literature* (Manchester: Manchester University Press, 1981), 49.

p. 11 'said Picasso': cit. Elizabeth Cowling, *Picasso: Style and Meaning* (London: Phaidon, 2002), 2.

'them': Cowling, ibid., 26.

p. 13 'another': cf. Marinetti's 'Destruction of Syntaxt: Imagination without Strings – Words in Freedom' (1913), in Umbro Apollonio (ed.), *Futurist Manifestos* (London: Thames and Hudson, 1973), 96.

Chapter 2: Modernist movements and cultural tradition

p. 17 'green': Kandinsky, *On the Spiritual in Art*, cit. Debbie Lewer (ed.), *Post Impressionism to World War II* (Oxford: Blackwell, 2006), 101.

'object': Desmond MacCarthy, preface to the catalogue of the 1910 exhibition, in J. B. Bullen (ed.), *Post-Impressionists in England* (London and New York: Routledge, 1988), 98.

'composition': Matisse, 'Notes of a Painter' (1908), in Jack D. Flam, *Matisse on Art* (London: Phaidon, 1978), 37.

p. 18 'communicative': as Jack D. Flam points out in *Matisse: The Man and His Art 1869–1918* (London: Thames and Hudson, 1986), 250–2.

p. 19 'enough': quotations from Roger Fry, 'The French Group' (1912) come from Bullen op. cit., 352–4. Also rpt. in Vassili Kolocotroni et al. (eds.), *Modernism: An Anthology of Sources and Documents* (Edinburgh: Edinburgh University Press, 1998), 189 ff. (This is a very useful and wide-ranging anthology which sees modernism in its European context.)

p. 21 'pictures?': Jelena Hahl-Koch, *Kandinsky* (London: Thames and Hudson, 1993), 253.

p. 23 'years': Joseph Rufer, *The Works of Arnold Schoenberg: A Catalogue of His Compositions, Writings and Paintings*, tr. Dika Newlin (London: Faber and Faber, 1962), 45.

'1924': This essay was later reprinted in the collection *Von neuer Musik* (Cologne, 1924).

'composition': Stephen Walsh, *Stravinsky: The Second Exile, France and America 1934–1971* (London: Jonathan Cape, 2006), 292; cf. 281.

'lengths': On the symbolic interpretation of this concerto, see e.g. Karen Monson, *Alban Berg* (London: Macdonald, 1979), 211–21.

p. 24 'role': John Milner, *Mondrian* (London: Phaidon, 1992), 161, 163.

'space': *De Stijl*, I, 2, 39, and II, 2, 40, rpt. in Hans L. Jaffe, *De Stijl* (London: Thames and Hudson, 1970), 31.

p. 25 'ratios': C. H. Waddington, *Behind Appearances* (Edinburgh: Edinburgh University Press, 1969), 42ff.

p. 27 '1918': see Joan Weinstein, *The Ends of Expressionisn: Art and the November Revolution in Germany, 1918–1919* (Chicago: Chicago University Press, 1990).

p. 28 'slave': cit. Frank Whitford, *Bauhaus* (London: Thames and Hudson, 1984), 128.
'soul': Calvin Tomkins, *Duchamp* (London: Chatto and Windus, 1997), 168.

p. 31 'band': Constant Lambert, *Music Ho! A Study of Music in Decline* (1934; reprinted London: Faber and Faber, 1966), 74.
'Bolsheviki': Stravinsky in an interview of 1925, cit. Scott Messing, *Neoclassicism in Music: From the Genesis of the Concept through the Stravinsky/Schoenberg Polemic* (Rochester, New York: Rochester University Press, 1988, 1996), 141.
'future': cit. Messing, ibid., 142.

p. 32 'illusion': Theodor W. Adorno, *The Philosophy of Modern Music* (London: Sheed and Ward, 1948), 64. The attack on neoclassicism as infantile is on 206f.
'age': Dermé, 'Quand le symbolisme fut mort', a programmatic statement for his *North South*, cit. Peter Nicholls, *Modernisms* (London: Macmillan, 1995), 243.
'structure': cit. Nicholls, ibid., 245.

p. 33 'possible': Igor Stravinsky and Robert Craft, *Expositions and Developments* (London: Faber and Faber, 1962, 1981), 113.
'caricature': Mikhail Ruskin, *Igor Stravinsky: His Personality, Works and Views* (Cambridge: Cambridge University Press, 1995), 47.
'space': Stravinsky, cit. Eric Walter White, *Stravinsky: The Composer and His Work* (Berkeley: University of California Press, 1979), 574f.
'artifice': Messing, op. cit., 133.

p. 34 'mourning': Elizabeth Cowling, op. cit., 425, 428f.

p. 36 'undesirable': John Berger, *Success and Failure of Picasso* (Harmondsworth: Penguin Books, 1965), 98.
'life': Michael Roberts, in his introduction to *The Faber Book of Modern Verse* (1936), rpt. Kolcotroni, op. cit., 514f.

p. 37 'creation': Stravinsky, *Poetics of Music* (Cambridge, Mass., and London: Harvard University Press, 1998), 56–7.

p. 38 'grateful': cit. Bram Djikstra, *Cubism, Steiglitz and the Early Poetry of William Carlos Williams* (New Jersey: Princeton University Press, 1969), 9.

References

p. 39 'false': Williams, 'Prologue' to 'Kora in Hell', in *Imaginations* (New York: New Directions, 1971), 14.

'exemplary': Djikstra, op. cit., 134, 165, 167f.

p. 42 'freethinking': James Joyce, *Stephen Hero* (London: Jonathan Cape, 1969), 96.

p. 43 'nihilistic': Mann, letter of 1915, cit. T. J. Reed, *Thomas Mann: The Uses of Tradition* 2nd edn. (Oxford: Oxford University Press, 1996), 237.

'heresy': J. P. Stern, *The Dear Purchase: A Theme in German Modernism* (Cambridge: Cambridge University Press, 1995), 29.

p. 45 'one': I. A. Richards, *Principles of Literary Criticism* (1926; rpt. London: Routledge and Kegan Paul, 1967), 233.

'war': C. Day Lewis, 'A Hope for Poetry' (1934), in C. B. Cox and Arnold P. Hinchcliffe (eds.), *T. S. Eliot: The Waste Land – A Casebook* (London: Macmillan, 1968), 58f.

p. 46 'art': T. S. Eliot, 'Ulysses, Order and Myth', *The Dial*, LXX, 5 (November 1923), 483.

p. 48 'materialized': Madame Blavatsky, 'The Secret Doctrine' (1888), extract rpt. Kolcotroni, op. cit., 32.

p. 49 'ritual': J. A. Symons, *The Symbolist Movement in Literature* (London: Heinemann, 1899), 9.

Chapter 3: The modernist artist

p. 52 'brain': Joyce, *Ulysses*, ed. Gabler, op. cit., 8: 21–6.

p. 53 'cabbageleaf': ibid., 8: 537–44.

'know': Woolf, 'Mr Bennett and Mrs Brown', in Andrew Mcneillie (ed.), *The Essays of Virginia Woolf*, vol. III (London: Hogarth Press, 1988), 385.

'all': Woolf, 'Character in Fiction', in ibid., vol. III, 427, 428.

p. 54 'June': Woolf, *Mrs Galloway* (Oxford: Oxford University Press, 1992), 4f.

p. 56 'epiphany': Joyce, *Stephen Hero* (London: Jonathan Cape, 1969), 218.

'wittily': Jeri Johnson (ed.), Joyce, *A Portrait of the Artist as a Young Man* (Oxford: Oxford University Press, 2000), 172, 178f.

p. 57 'St Ives': Jeanne Schulkind (ed.), Virginia Woolf, *Moments of Being* (London: Grafton, 1989), 79–81.

p. 58 'all': Virginia Woolf, *To the Lighthouse* (Oxford: Oxford University Press, 1992), 217, 231, 272.

p. 59 'now': T. S. Eliot, 'Burnt Norton', *The Complete Poems and Plays of T. S. Eliot* (London: Faber and Faber, 1969), 175.

'sciences': Frank Kermode, *Romantic Image* (London: Routledge, 1957), 157.

p. 61 'chance': Jean-Paul Sartre, *Nausea*, tr. Robert Baldick (Harmondsworth: Penguin Books, 1965), 60, 63, 82, 182f., 185, 191.

p. 62 'life': J. P. Stern, *The Dear Purchase* (Cambridge: Cambridge University Press, 1995), 30.

'us': Thomas Mann, *The Magic Mountain*, tr. H. T. Lowe-Porter (Harmondsworth: Penguin Books, 1953), 495ff.

p. 63 'witnesses': Ricardo Quinones, *Mapping Literary Modernism* (New Jersey: Princeton University Press, 1985), 92, 95.

'consciousness': Charles Russell, *Poets, Prophets and Revolutionaries* (New York: Oxford University Press, 1985), 10.

'penetrated': Franz Kafka, *The Trial*, tr. Willa and Edwin Muir (Harmondsworth: Penguin Books, 1953), 250f.

p. 64 'man': Quinones, ibid., 95f.

'experience': Quinones, ibid., 105.

p. 65 'element': George K. Zykaruk and James T. Boulton (eds.), *The Letters of D. H. Lawrence*, vol. ii (Cambridge: Cambridge University Press, 1981), 183.

'them': in a review in *The Nation and Athenaeum*, 13 August 1921, rpt. Colin Clarke (ed.), *D. H. Lawrence, The Rainbow and Women in Love: A Casebook* (London: Macmillan, 1969).

'triumph': D. H. Lawrence, *The Rainbow* (Oxford: Oxford University Press, 1997), 319f.

p. 66 'circulation': see John Werthen, *D. H. Lawrence* (London: Allen Lane, 2005), 164.

'[ch xv]' I follow S. L. Goldberg, 'The Rainbow: Fiddle and Sand, *Essays in Criticism*, XI, no. 4 (1961), rpt. in Clarke (ed.), op. cit., 120.

p. 67 'being': Julian Moynihan, 'Ritual Scenes in *The Rainbow*', rpt. Clarke (ed.), op. cit., 149.

p. 69 'fascination': Douglas Jarman, *Alban Berg: Wozzeck* (Cambridge: Cambridge University Press, 1989), 44 (on the fugue) and 21.

p. 70 'life': André Breton, 'The First Surrealist Manifesto' (1924), in *André Breton: Manifestos of Surrealism* (Ann Arbor: University of Michigan Press, 1972), 26.

p. 71 'reason': ibid., 9f.

p. 72 'mind': rpt. in Kolocotroni et al. (eds.), *Modernism: An Anthology of Sources and Documents* (Edinburgh: Edinburgh University Press, 1998), 601ff.

p. 73 'suicide': Ruth Brandon, *Surreal Lives: The Surrealists 1917–1945* (London: Macmillan, 1999), 317f and 330.

'member': Sigmund Freud 'Fetishism' (1927), in *On Sexuality*, Penguin Freud Library, vol. 7 (Harmondsworth: Penguin Books, 1977), 354.

p. 75 '1936': Jennifer Mundy (ed.), *Surrealism: Desire Unbound*, exh. cat. (London: Tate Publishing, 2001), 45.

p. 76 'details': Ian Gibson, *The Shameful Life of Salvador Dali* (London: Faber and Faber, 1997), 215f.

p. 77 'discovering': Wallace Stevens, *Opus Posthumous* (London: Faber and Faber, 1969), 177.

'lying': Christopher Isherwood, *Lions and Shadows* (London: Signet, 1968), 185.

p. 78 'breakfast': W. H. Auden, *The Orators* (London; Faber and Faber, 1966), 93.

p. 79 'destiny': W. H. Auden, 'Psychology Today' (1935), in Edward Mendelson (ed.), *The English Auden* (London: Faber and Faber, 1977), 340f.

Chapter 4: Modernism and politics

p. 81 'complication': I follow Brandon, op. cit., 262ff. For a full account, see Gerard Duruzoi, *History of the Surrealist Movement*, tr. Alison Anderson (Chicago and London: Chicago University Press, 2002), 189–235.

p. 82 'law': Arthur Koestler, *Darkness at Noon* (Harmondsworth: Penguin Books, 1964), 41, 82.

'abnormal': cf. the account of Lukács in Astradur Eysteinsson, *The Concept of Modernism* (Ithaca and London: Cornell University Press, 1990), esp. 29.

p. 83 'people': Lukács, 'Realism in the Balance' (1938), rpt. in Kolcotroni et al., op. cit., 584ff.

'1960s': Eric Kaufmann in *Prospect* magazine, November 2006, 30.

'communion': in his 'A Hope for Poetry' (1934), in Kolcotroni, op. cit., 489.

p. 84 'communism': Orwell, 'Inside the Whale' (1940), ibid., 607.

'poetry': Day Lewis, ibid., 492.

p. 85 'life': Alex Ross, *The Rest is Noise* (London: Fourth Estate, 2008), 203–4.

p. 87 'dadaists': Peter Adam, *The Arts of the Third Reich* (London: Thames and Hudson, 1992), 123.

p. 88 'abolished': excerpts from Hitler's speech are cited from Kolcotroni, op. cit., 560–3. The German text of the speech is in Peter Klaus Schuster (ed.), *Die 'Kunststad' Munchen 1937 – Nationalsozialismus und 'Entartete Kunst'* (Munich: Prestel, 1987), 242–53.
'being': Winfried Wendland, *Kunst und Nation* (Berlin: Verlag der Raimer Hobbing, 1934), 19, cit. Adam, op. cit., 95.
'life': cit. Adam, op. cit., 95f.

p. 89 'Word': these paintings (along with many others) are reproduced in Adam, op. cit., 26, 51, 172.

p. 90 'thought': a press spokesman for the Ministry of Information (1937), cit. Adam, op. cit., 16.
'cultural life': cit. Adam, op. cit., 69.
'spiritual life': Paul Fechter, cit. Ronald Taylor, *Literature and Society in Germany 1915–1945* (Brighton: Harvester, 1980), 244.

p. 92 'vision': Charles Russell, *Poets, Prophets and Revolutionaries* (New York and Oxford: Oxford University Press, 1985), 113.
'style': Diana Crane, *The Transformation of the Avant-Garde: The New York Art World, 1940–1985* (Chicago: Chicago University Press, 1987), 1.

p. 93 'Greenberg': notably in his essays 'Modernist Painting' (1961) and 'After Abstract Expressionism' (1962), rpt. in Charles Harrison and Paul Wood (eds.), *Art in Theory 1900–1990* (Oxford: Blackwell, 1992).

p. 94 'row': Derek B. Scott, 'Introduction', in Derek B. Scott (ed.), *Music, Culture and Society* (Oxford: Oxford University Press, 2000), 11.

p. 96 'expressionism': Grosz, cit. Beth Irwin Lewis, *Georg Grosz: Art and Politics in the Weimar Republic* (New Jersey: Princeton University Press, 1991), 53.

p. 98 'romanticism': Grosz, cit. Hans Hess, *George Grosz* (New Haven and London: Yale University Press, 1985), 101f.
'weapon': Carl Einstein 'Otto Dix', *Das Kunstblatt*, vol. 7 (1923), 97.

p. 100 'shield': Christopher Green, *Art in France 1900–1940* (New Haven: Yale University Press, 2003), 335.

'work': Tim Hilton, *Picasso* (London: Thames and Hudson, 1975), 246.

'aesthetes': Blunt, cit. Green, op. cit., 286.

p. 101 'considerable': Green, op. cit., 289.

p. 102 'masterpiece': cf. e.g. Gijs van Hensbergen, *Guernica: The Biography of a Twentieth Century Icon* (London: Bloomsbury, 2005).

Further reading

In addition to the references cited in the notes, the following are recommended:

Chapter 1: The modernist work

For the politics of *Ulysses*, see, *inter alia*, Andrew Gibson, *Joyce's Revenge: History, Politics and Aesthetics in Ulysses* (Oxford: Oxford University Press, 2002). On the relationship of early modernist painting to popular culture, see for example Jeffrey Weiss, *The Popular Culture of Modern Art* (New Haven and London: Yale University Press, 1994). On Picasso's stylistic evolution, and much else, see Elizabeth Cowling, *Picasso: Style and Meaning* (London: Phaidon, 2002). On the development of Léger's painting, see Christopher Green, *Léger and the Avant Garde* (New Haven and London: Yale University Press, 1976). For a study of technical innovation in the arts, see Christopher Butler, *Early Modernism: Literature, Music and Painting in Europe 1900–1916* (Oxford: Clarendon Press, 1994).

Chapter 2: Modernist movements and cultural tradition

On Picasso and Matisse, see Elizabeth Cowling et al. (eds.), *Matisse/Picasso*, exh. cat. (London: Tate Publishing, 2002). On Diaghilev, see for example Lynn Garafola, *Diaghilev's Ballets Russes* (New York and Oxford: Oxford University Press, 1989), and Lynn Garafola and Nancy Van Norman Baier (eds.), *The Ballet Russe and Its World* (New Haven and London: Yale University Press, 1999). On the development of

cubism, see William Rubin (ed.), *Picasso and Braque: Pioneering Cubism*, exh. cat. (New York: Museum of Modern Art, 1989).

On Kandinsky's 'Compositions', see Magdalena Dabrowski, *Kandinsky Compositions* (New York: Museum of Modern Art, 1995). And also Hartwig Fischer and Sean Rainbird (eds.), *Kandinsky: The Path to Abstraction*, exh. cat. (London: Tate Publishing, 2006).

On the Bauhaus, see the documents and pictures in Hans Wingler, *The Bauhaus* (Cambridge, Mass., and London: Massachusetts Institute of Technology Press, 1978). On Duchamp and Picabia in America, see Steven Watson, *Strange Bedfellows: The First American Avant Garde* (New York: Abbeville Press, 1991) and Calvin Tomkins, *Duchamp* (London: Chatto and Windus, 1997). On the allegedly conservative aspects of post-war neoclassicism, see for example Kenneth E. Silver, *Esprit de Corps: The Art of the Parisian Avant Garde and the First World War, 1914–1925* (London: Thames and Hudson, 1989). On the modernist preoccupation with primitivism, see for example William Rubin (ed.), *Primitivism in Twentieth Century Art*, 2 vols (New York: Museum of Modern Art, 1984). Also Robert Goldwater, *Primitivism in Modern Art* (Cambridge, Mass., and London: Harvard University Press, 1986; first published 1938); Marianne Torgovnik, *Gone Primitive: Savage Intellects, Modern Lives* (Chicago and London: Chicago University Press, 1990); and J. Lloyd, *German Expressionism: Primitivism and Modernity* (New Haven and London: Yale University Press, 1991).

On the devlopment of modernist music in America, see Carol J. Oja, *Making Music Modern* (New York and Oxford: Oxford University Press, 2000). On the relationship of modernist music to earlier models, see for example Joseph N. Straus, *Remaking the Past: Musical Modernism and the Influence of the Tonal Tradition* (Cambridge, Mass.: Harvard University Press, 1990). For some appreciation of the many influences on *The Waste Land*, see Lawrence Rainey (ed.), *The Annotated Waste Land, with Eliot's Contemporary Prose*, 2nd edn. (New Haven and London: Yale University Press, 2006) and his *Revisiting The Waste Land* (New Haven and London: Yale University Press, 2005), on the process of its composition. On Freud as atheist, see Peter Gay, *A Godless Jew: Freud's Atheism and the Making of Psychoanalysis* (New Haven: Yale University Press, 1987).

Chapter 3: The modernist artist

On modernist literature in Germany, see J. P. Stern, *The Dear Purchase: A Theme in German Modernism* (Cambridge: Cambridge University Press, 1995); Ronald Taylor, *Literature and Society in Germany 1915–1945* (Brighton: Harvester, 1980); David Midgley, *Writing Weimar: Critical Realism in German Literature 1916–1933* (Oxford: Oxford University Press, 2000); Wolf Lepennies, *The Seduction of Culture in German History* (New Jersey: Princeton University Press, 2006).

On the sexual ramifications of surrealism, see Jennifer Mundy (ed.), *Surrealism: Desire Unbound*, exh. cat. (London: Tate Publishing, 2001). On the irrationalist tradition in poetry, see Marjorie Perloff, *The Poetics of Indeterminacy: Rimbaud to Cage* (New Jersey: Princeton University Press, 1981). On the influence of Dada, see Richard Sheppard, *Modernism, Dada, Postmodernism* (Evanston, Illinois: Northwestern University Press, 2000). On surrealism in England, see Michel Remy, *Surrealism in Britain* (Aldershot: Ashgate, 1999). On the history of the surrealist movement, see Gerard Duruzoi, tr. Alison Anderson, *History of the Surrealist Movement* (Chicago and London: Chicago University Press, 2002).

Chapter 4: Modernism and politics

For a study of Western Marxism, see the volume of that title by J. G. Merquior (London: Fontana, 1986), and for a study of the interaction of Marxism and modernism, see Eugene Lunn, *Marxism and Modernism* (London: Verso, 1985). On the political reactions of British writers, see Valentine Cunningham, *British Writers of the Thirties* (Oxford: Oxford University Press, 1988). The effects of the modernist revolution on Russian art are recounted in Camilla Gray, *The Russian Experiment in Art 1863–1922*, rev. edn. (London: Thames and Hudson, 1986). See also Igor Golomstock, *Totalitarian Art in the Soviet Union, the Third Reich, Fascist Italy and the People's Republic of China*, tr. Robert Chandler (London: Collins Harvill, 1991), chapters 1 to 3. For an account of popular culture and of modernist responses to it, see Noel Carroll, *A Philosophy of Mass Art* (Oxford: Oxford University Press, 1998). An interesting account of the failure of modernism to sustain a consistently socialist development is to be found in T. J.

Clark's *Farewell to an Idea: Episodes from a History of Modernism* (New Haven and London: Yale University Press, 1999). A pioneering study of female social groupings is to be found in Georgina Taylor, *H. D. and the Public Sphere of Modernist Women Writers 1913–1946* (Oxford: Oxford University Press, 2001). On the continuing tradition and importance of realist art in all periods, cf. Brendan Prendeville, *Realism in Twentieth Century Painting* (London: Thames and Hudson, 2000).

Also of interest are David Peter Corbett, *Modernism and English Art* (Manchester: Manchester University Press, 1997) and Lisa Tickner, *Modern Life and Modern Subjects* (New Haven: Yale University Press, 2000). On abstraction, see John Golding, *Painting and the Absolute* (London: Thames and Hudson, 2000). On music in the 20th century, see Alex Ross, *The Rest is Noise* (London: Fourth Estate, 2008), Glenn Watkins, *Pyramids at the Louvre: Music, Culture and Collage from Stravinsky to the Postmodernists* (Cambridge, Mass., and London: Harvard University Press, 1994), and Richard Taruskin, *The Oxford History of Western Music*, vol. 4, *The Early Twentieth Century* (New York and Oxford: Oxford University Press, 2005). Stephanie Barron (ed.), *'Degenerate Art': The Fate of the Avant Garde in Germany*, exh. cat. (Los Angeles: Los Angeles County Museum of Art, 1991). And for music in Germany in this period, see Michael Kater, *Composers of the Nazi Era* (New York and Oxford: Oxford University Press, 2000).

Index

Index

CLASSICS
A Very Short Introduction
Mary Beard and John Henderson

This Very Short Introduction to Classics links a haunting temple on a lonely mountainside to the glory of ancient Greece and the grandeur of Rome, and to Classics within modern culture – from Jefferson and Byron to Asterix and Ben-Hur.

'The authors show us that Classics is a "modern" and sexy subject. They succeed brilliantly in this regard … nobody could fail to be informed and entertained – and the accent of the book is provocative and stimulating.'

John Godwin, *Times Literary Supplement*

'Statues and slavery, temples and tragedies, museum, marbles, and mythology – this provocative guide to the Classics demystifies its varied subject-matter while seducing the reader with the obvious enthusiasm and pleasure which mark its writing.'

Edith Hall

MUSIC
A Very Short Introduction
Nicholas Cook

This stimulating Very Short Introduction to music
invites us to really *think* about music and the values
and qualities we ascribe to it.

> 'A *tour de force*. Nicholas Cook is without doubt one of
> the most probing and creative thinkers about music we
> have today.'
> ### Jim Samson, University of Bristol

> 'Nicholas Cook offers a perspective that is clearly influ-
> enced by recent writing in a host of disciplines related
> to music. It may well prove a landmark in the appreci-
> ation of the topic … In short, I can hardly imagine it being
> done better.'
> ### Roger Parker, University of Cambridge

www.oup.co.uk/vsi/music

PSYCHOLOGY
A Very Short Introduction
Gillian Butler and Freda McManus

Psychology: A Very Short Introduction provides an up-to-date overview of the main areas of psychology, translating complex psychological matters, such as perception, into readable topics so as to make psychology accessible for newcomers to the subject. The authors use everyday examples as well as research findings to foster curiosity about how and why the mind works in the way it does, and why we behave in the ways we do. This book explains why knowing about psychology is important and relevant to the modern world.

'a very readable, stimulating, and well-written introduction to psychology which combines factual information with a welcome honesty about the current limits of knowledge. It brings alive the fascination and appeal of psychology, its significance and implications, and its inherent challenges.'

Anthony Clare

'This excellent text provides a succinct account of how modern psychologists approach the study of the mind and human behaviour. ... the best available introduction to the subject.'

Anthony Storr

www.oup.co.uk/vsi/psychology